THE ART & DESIGN SERIES

For beginners, students, and professionals in both fine and commercial arts these books offers practical how-to introductions to a variety of areas in contemporary art and design.

Each illustrated volume is written by a working artist, a specialist in his or her field, and each concentrates on an individual area—from advertising layout or print-making to interior design, painting and cartooning among others. Each contains information that artists will find useful in the studio, in the classroom, and in the marketplace. Among the titles:

Hiram Williams is Distinguished Service Professor Emeritus of Art at the University of Florida. His work is included in museum collections across the country, including the Whitney Museum of American Art in New York, the Museum of Modern Art in New York, the Solomon R. Guggenheim Museum in New York, and the National Gallery of Art in Washington, D.C.

HIRAM WILLIAMS

Notes for a Young Painter

A revised and expanded edition of
a classic handbook for beginning artists

A SPECTRUM BOOK

PRENTICE-HALL, INC.,
Englewood Cliffs, New Jersey 07632

Library of Congress Cataloging in Publication Data

WILLIAM, HIRAM.
 Notes for a young painter.

 "A Spectrum Book."
 Bibliography: p.
 1. Painting—Technique. I. Title.
ND1500.W5 1984 751.4 83-24462
ISBN 0-13-6241239-9
ISBN 0-13-624115-8 (pbk.)

This book is available at a special discount when ordered in bulk quantities. Contact Prentice-Hall, Inc., General Publishing Division, Special Sales, Englewood Cliffs, N.J.. 07632.

10 9 8 7 6 5 4 3 2 1

Production/editorial supervision
 and interior design by Jane Zalenski
Manufacturing buyer: Doreen Cavallo
Cover design by Hal Siegel

Cover art: *Scurrying Man*, Hiram Williams
(Collection of Kim Williams Boyd. Photograph by Roy Craven.)

ISBN 0-13-624115-8 {PBK.}

ISBN 0-13-624123-9

PRENTICE-HALL INTERNATIONAL, INC., *London*
PRENTICE-HALL OF AUSTRALIA PTY. LIMITED, *Sydney*
PRENTICE-HALL CANADA INC., *Toronto*
PRENTICE-HALL OF INDIA PRIVATE LIMITED, *New Delhi*
PRENTICE-HALL OF JAPAN, INC., *Tokyo*
PRENTICEpHALL OF SOUTHEAST ASIA PTE. LTD., *Singapore*
WHITEHALL BOOKS LIMITED, *Wellington, New Zealand*
EDITORA PRENTICE-HALL DO BRASIL LTDA., *Rio de Janeiro*

Contents

Preface

Herein are notes, jottings, and lectures strung together and more or less woven into portions of the manuscript that was published by Prentice-Hall, Inc. in 1963 as *Notes for a Young Painter*. Some were written for brochures; some are essays written for my student seminars or as speeches to be given as I spoke at one campus or another. They belong together, however, because they were written about the art of painting for people like you, who are thinking about a career in art or are already into the early stages.

Much of the material I present has been delivered to people more advanced than you, but I thought it would be condescending of me to simplify; besides, the only problem I foresee is mentioning names unfamiliar to you. You are going to learn of these artists anyway. Why not start here?

I hope that those of you who are thinking about an art career will be helped to make up your mind to do so or not to do so, and those of you who are committed find my advice and information, opinion and prejudice worth your time.

Acknowledgments

I wish to thank the former students and art faculty who have permitted me to reproduce their work. At the same time, I must apologize to dozens of artist friends for not soliciting their work for reproduction. Those paintings that have been reproduced herein have not been selected as the best of the lot, but by luck of the draw.

Certain persons have been unfailing supporters of mine in this and other instances: Robert Bryan, Robert Mautz, Joseph Sabatella, Harold Hanson, William Chandler, Donald Weismann, Walter Herbert, Gordon Whaley, Kenneth Kerslake, Robert Larson, and Joseph Jeffers Dodge. These names come to mind, but there are many others.

Introduction

Can verbal advice save the young painters time? Can their progress be helped by suggestion? Or must painters, every painter, grapple in a catch-as-catch-can fashion with the stuff tradition has given them to fashion their own images? Certainly some time is bound to be wasted, for this is in the nature of search. Yet it would seem that guidance might make the detours less extensive, less arduous and painful. Not that difficulties are not inherent in the struggle to attain a personal image, nor would it be wise were they somehow to be completely removed. It is my thought, however, that perhaps these difficulties might be made less numerous with proper counsel. It is the purpose of these notes to provide that counsel, to help young painters to exercise their talent so that their energy is not completely wasted. It is amazing the way time passes by for creative people. Today they are young, healthy, and afire with eagerness; tomorrow they find life has passed them by, and they look back on hopes smashed, shattered by the futilities of their abortive efforts.

It is currently in vogue to approach art in an existential abandon, to assume the stance that art is a momentary activity and that the purpose of any of its works is to provide another moment in a sequence of shocks. The supposition is that a sequence of titillations adds up to living art. This viewpoint does recognize that art's purpose is to vitalize life, but it overlooks one of the essentials of art: that art by its nature requires of its works that they pose as absolutes—things qualitative, positive, and enduring. It follows,

then, that artists must approach their work in a responsible frame of mind with the hope that what they make will contribute to the mainstream of art forms. When all is said and done, we must agree that artists are making a contribution to our culture. Whether it is an important contribution lies in their own hands. We are not so simple-minded as to suggest that a responsible attitude is enough or that heeding good advice, even the most nearly infallible advice, can insure that aspiring painters come up with superior art. Unfortunately, desire responsibly directed is not enough. Intelligence is not enough. Talent is necessary. Talent includes an order of artistic intelligence, the ability to develop a "thinking hand," and the possession of an eidetic imagination, which is an ability to cast an imagined image into material form. It seems to me that if you have these capacities, plus need, the chances are good that you can become a fine painter, perhaps even a great one.

I understand that the greatest mathematicians spend their later careers developing ideas they generated while in their twenties. By and large this is true of the creative artists, of painters. There are exceptions, like Jackson Pollock, who came upon his best idea in middle life; but Pollock is an exception who proves the rule. Most painters must build the future of their art upon ideas found when they were young, in their twenties or early thirties. I tell my university classes to create "soups" of ideas, to think of pictorial forms from every conceivable vantage point. I tell them to pursue ideas that at the time seem foolish, impossible. These ideas will lie fallow and in later years will be remembered in transformed and useful shapes. Therefore, perhaps the most important part of your program as a developing artist is right now. Along with technical discipline you must exercise your imagination to provide form and substance upon which you will be dependent in your mature years. If you do not do this for yourself, you will do what so many painters are forced to do: you will be forced to ride the coattail of a creative neighbor.

Notes for a Young Painter

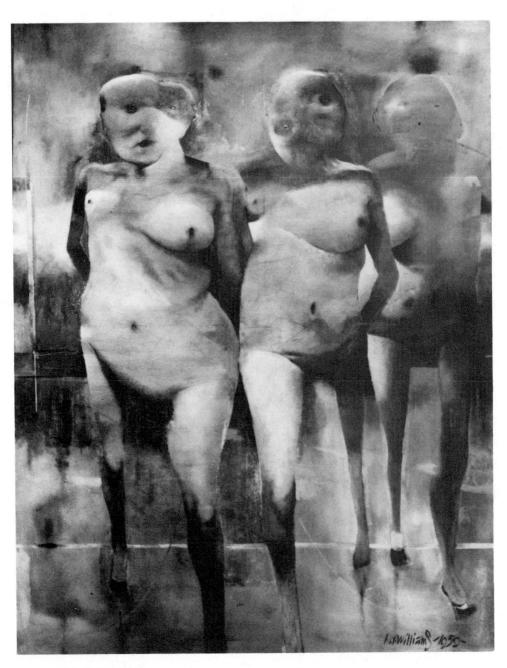

HIRAM WILLIAMS
Three Nudes Oil, 8′ × 6′, 1959
Collection of Kim Williams Boyd.

1.

The Painter's Goal

Art is created out of need. Driven by need, untrained but imaginative people can accomplish creative wonders.

Naive painters, creative artists such as Grandma Moses, are able to express themselves without benefit of art education. Like God, Grandma Moses made trees: First, the trunk, then branches, then twigs, and, finally, leaves.

A naif named Black, a Tennessean, built a tourist trap in the American southwest. He called it Possum Trot. He fashioned from wood scraps crude life-sized female mannequins, dressed them in clothes from Goodwill, fitted them to shafts turned by the wind, placed amplifiers under their hats and wigs, and set them in a row atop a platform. Thirty animated life-sized dolls accompanied by his violin sang via tapes as they rapidly moved their arms and legs in unison. I verily believe that there is no way to create a more moving art.

Witness also the painting of "Le Dounier" Rousseau, or the painting of John Kane, the Pittsburgh house painter, who depicted *The Golden Triangle* and its environs as well as it can be done.

Need is not enough, however. Need must find idea and method. Most of us require an education in art before we can locate idea and method.

As do so many, Francis Bacon, a leading British figurative painter, has declared that he is self-taught. This is true in the sense that Bacon did

not attend art schools to pursue batteries of courses. What he did not say is that he had the luck, or asperity, to be active in the art circles of Paris, Berlin, and London between the Great Wars. Tell me, where would he have gotten a better education in art?

Alberto Giacometti did have formal art education both in painting and sculpture. In time he found idea and method and *obsession*. Alberto Giacometti became obsessed with "interval," with what distance does to the appearance of a figure. In the John DeMenil Collection he has a sculpture seven inches high. The viewer may stand close to a sculpture seven inches high or seven feet high, and the experience will be the same. Both will feel distant. I have never seen anyone touch a Giacometti.

All aspirants in the creative arts feel need for expression. Note, however, that Giacometti sculpted *under the aegis of an idea*. Obsession cannot occur before idea. Need must find idea and method; obsession follows. Desire for expression, then, is nothing without idea.

As idea leads, the form of one's art emerges, and at its best, an accumulation of painted images leads to a surrogate of the real world, surrogates such as the world of Miró, of de Kooning, of Burchfield, of Edwin Dickinson, of Jasper Johns. Speak of "style" if you will, it comes to the same thing. Speak of "vision," it comes to the same thing.

Idea is the hinge upon which a painting swings. Intention is discovered when idea is embodied in the medium.

Artists must determine measures in technique that correspond to their feelings. This means that as they try different ways of handling surface and elements of image, they accept or reject what they are doing through their emotional reaction to it; in other words, they like or dislike the way in which a painting is shaping up. As they experiment, they eventually find they have formed a mental image that will govern the future of the painting. Artists will find that they can now see in what manner to present the converted idea (the "intention"). In fact, they may form several such mental images—several concrete manners in which to present the objectification of the idea. After considerable play through their mediums, they will choose the one emotionally acceptable to them.

When talking to painters exhibiting their pictures, one often hears one of them say that he or she intends to rework a painting in a different manner upon its return to the studio. At the exhibition, he has found that he feels an emotional dissatisfaction with the painting; he has found himself out of rapport with the picture's development. At worst, the painter may find himself disillusioned with his idea. It is not unknown for painters to destroy their prize-winners after they are returned to their studios.

2.
Why and
What is Art?

We ask or hear the question: What is art? Can we call such and such an object "art"?

Twice in my lifetime the work of El Greco has been in ascendency as critical attention brought public interest to focus upon it. Twice artists and art students have grown excited about the great anti-reformation painter's output. What happened? Why the renewed enthusiasm?

A number of factors may have been the cause. Perhaps there was recognition that El Greco's form was prophetic to modern form. Perhaps collector, museum, and critic colluded, and their creation of publicity heightened the public's awareness of the Greek; so, for a period of time everyone thought that what painting should be, seemed to have been concreted in El Greco's form. Sooner or later, however, interest wanes—shifts—another hero of art appears and we are stirred by the work of another. The same for movements.

Picasso convinced us that a bicycle seat and handlebars could be labeled sculpture representing a fighting bull. Duchamp moved a urinal from a latrine to a gallery and called it sculpture. Five or six bricks have been laid in a row in a gallery and called art. A ditch was dug into a desert waste, and some marvel at it as the very height of expression. A warped stretcher supports a tattered canvas hung from the wall of one of our major museums, a couple of bare tree limbs lean against the canvas. This is art?

3

What we respond to, changes as art changes; therefore, we are advised to play mum when asked what is art. We're better advised to explain what art *does;* its purpose.

One certainty is that works of art—literature, music, the visual arts—have "form." Form occurs in ritual. Form occurs in a football game, and to that extent such a game can be seen as art.

Watch an afternoon of football unfold. Behold the excitement as crowds pour toward and into the stadium; see the ticket scalpers scalping, the alumni drunks well on their way toward oblivion; observe the press of people as they find their seats. All are gladdened by the colorful bands on the sidelines, by the pompon girls, the cheerleaders, and the mascots. Heads bow for the invocation. In unison all rise for our national anthem (Oh, my God: Hope the soloist clears that high note!). Soon every eye strains as the teams appear from underneath the stadium. The fourth or fifth string appears as tension mounts. They charge up field. The third string appears and applause grows louder. The second string appears and the atmosphere is vibrant with excitement. Finally, the first team appears, big as gorillas. They charge up field as the crowd roars.

Coins are tossed and the teams are joined. The contest unfolds between the two as execution follows execution, as a series succeeds or is checked. The game takes on form even as preliminaries to the game had form. If a good game, it will be imbued with an aesthetic character. Halftime has its rituals: Bands spread, unfold, march. Pattern and play continue until its end, but for what purpose?

To give, I answer, through form, emotional meaning to a few hours on a Saturday afternoon or evening!

The same goes for art. Through form, emotional meaning is given to stuff drawn from out of the chaos of life's experience. Without art—form and ritual—human life would consist of ingestion, digestion, and animal procreation. Mankind would exist at the cultural level of Digger Indians.

Works of art have their season; their days in the sun or days of eclipse. Their audiences are warmed by them and then grow cool. Nevertheless, the art has done its part, fixed itself in the memory of the audience and in so doing literally added a dimension to their experience, made their lives larger. It vitalized their lives.

This is why we've turned to painting, to make a career of it. We wish to thrill others as we have been thrilled. Andre Malraux was right when he wrote that artists are in art for the love of it.

But how will we go about finding the shape and way of our images, the make-up of our vision?

3.
The Painter's Personality

Perhaps we'd better take a look at ourselves, for psychology has found us out. We tend to be passive personalities. All of our lives we have more than the ordinary need for a strong father figure, someone we can lean on for moral support. We avoid day-to-day affairs largely because we are incompetent; we feel too inept to cope with run-of-the-mill business problems. If we gamble, we do it to lose. It's been disputed, but as Harry Clurman said, "His art is the health of the artist," and I'm inclined to agree. Seems to me every good painter I've met is to some degree ill. The bad painters I've met strike me as mostly healthy and would do well somewhere on Wall Street, at IBM, or at General Motors.

4.

The Painter and Society

Many of us who paint earn our living in a practical world, a world of rigorous demands: a world where some kind of accounting must be done. A world data must be compiled, reports rendered, material memorized and organized, and activity engaged in, business must be accomplished. If my own experience is any criterion, painters, while immersed in a creative period, are hopelessly lost among the affairs of the real world. Like children, they are out of contact with adult areas of practical engagement. We find ourselves unable to compile a report, unable to order facts, unable to cope intelligently with organization. We discover ourselves unable to encounter society at any but the simplest levels.

5.

Processing a Painting

It will not hurt to examine what I refer to as the "creative dialogue." It is a true dialogue, a give and take between painter and a developing image on canvas as the painter attempts to exert his or her will though the image begs to differ.

Painters are the sum total of their art/life experiences. They have good to excellent hand and eye coordination; have a nervous system primed for argument; have a rational, conscious mind; and an intuitive, subconscious mind (the right brain?) that ferments (we hope) with creative answers to art problems. Painters are constructive, building people and at the same time are destructive wreckers capable of going berserk. Painters begin to apply paint to canvas, have thumbnail sketches of the idea, or perhaps prior painting in series, that indicate a successful painting is to be theirs for the making. Painters proceed, having planned the order in which to use materials. All goes well, the painting develops. The painting suggests directions and from somewhere among deep layers of the painters' brains come advice. The painters' hands seem to be in charge. Fine.

We have all noticed that when we touch our brushes to canvas our minds seem to become cotton-like, stuffed. We cling for dear life (if we are smart) to our idea even as the emerging image advises us to move from it. A painting can suggest options to the painter that if heeded, can lead to disaster.

6.

Surface Treatment

When we write of "process," we are introducing these questions: "What do I do when I paint? I must fill in, somehow, each square inch of canvas. How should the brush strokes run? Up and down? Horizontally?" When all is said and done surface treatment does have bearing upon the final character of a finished picture. Surface treatment exemplifies the measures of action a painter has practiced during the creation of a picture. Surface treatment can indicate an attitude of the creator—one of cold calculation, one of frenzy, one of poetic sensibility. Surface treatment can be as instrumental to the progress and final sense of the picture as connecting words can be to the writer. How different are the short, clipped sentences of Hemingway compared to those long, convoluted sentences of Faulkner. The very structure of their sentences, their tone, declares the "set" of the writers' minds as they pursue their way—word by word, sentence by sentence, paragraph by paragraph—through the creative envolvement of their stories. This attitude, this set, is revealed stroke by stroke as painters evolve their pictures. While this set is of critical importance to the final presence of the created picture, any surface treatment is no more than rendering if it is not part and parcel of the intention discovered as painters seek to embody their ideas. The idea, then, must dictate the manner of surface treatment.

Words are like bricks building up to an architect's idea of a building—the variety, color, size, and placement of the bricks can determine the final appeal of the building. Variety, color, size, and placement of brush strokes can determine the final appeal of the picture; but even so, idea really makes the building, idea makes the story, and idea makes the picture. The danger for students is that they may think that laying bricks will make the building, but a building is an idea concerning form and function, and the idea must dictate the fashion and arrangement of the bricks. The choice of words must seem right for the idea of the story, and the choice of a proper handling of paint must appear to agree with the nature of a picture. Form and content must be inseparable.

7.
How We Fund a Painting

We know a painting through its impact and yield of sensations, through its believability as a "truth," as insight, as a focus upon a facet of experience hitherto not mirrored or transformed in this particular way. We may identify with it as an experience itself. In participation with the creative painting we ourselves become transformed, if only for a moment. We are risen out of the commonplace to a kind of difference from our usual selves. The sense of new self gone, our old self returns; but a residue, a trace of the shared created moment, remains behind. Our old selves will never be quite the same. We are yet our old selves but with a difference.

So constituted are we that our wonder, our experiencing of art is motivated by the simplest means. A painting physically is primitive but so is human perception. The perception of a painting may provoke in the viewer a yield of experience out of all proportion to the physical fact. A work of art is greater than the sum of its parts. Painters knew this long before Gestalt psychology came into being.

What the painting does to us! Rather, what we as viewers do to ourselves because of it, for it is we who create the work of art, in ourselves, through ourselves. Given pretext to act upon ourselves, we act. It takes all three—the creator, the work of art, and the viewer—to cause the aesthetic moment. Conceivably the viewers are the most important. They create the vital minute in their brains and nervous systems, both conditioned by

experience. An amplification of simple measures takes place and the viewers resonate with the painting.

We, of course, experience other than art in the same way. To return to the football game, all spectators at a ballgame have a ballgame of some kind—similar to the one they are watching and hearing—inside their heads.

Aesthetic responses may occur in all sorts of circumstances, including our game. The difference is that the work of art is designed from its inception to bring about the creative participation of a public. No one can deny that the ballgame inside one's head may be a thing of beauty. Ballgames have fresh and vital moments.

In a ballgame, skill and luck determine the outcome. The semblance of art can be there—the form, the order of perfect execution. Perfect execution joined with the emotion of the game can lift the spectator to a heightened awareness. The game in the spectator's mind becomes like none other. But art does not exist there as art. The game is a game, repeated over and over, over years (some good, some bad). Seldom does the game have a creative instance, while art abounds with creative instances. That game in the spectator's mind may seem to be the finest ever witnessed—at least it seems so at the time. But seldom is the game memorable; seldom is it singular. Next week, or the folowing week, an almost identical game will be played on the field and in the spectator's mind.

But the good painting is memorable. The singular nature of the stimulus (the painting) imprints itself in mental corridors where all such impressions are stored—stacked in rows, no doubt. The impressions will act as referential aid when next we confront a painting, as aid when next we, as viewers, participate in the art experience.

8.
The Painter's Stance

Picasso, when asked why he used so much green, replied that he had walked through the woods that morning and upon his return had had to "vomit green." Asked about lurid color combinations in another painting, he said that those conjunctions had happened simply because he had used color from tubes closest at hand.

In the first instance the painter reacted to the phenomenal world directly. In the second he was involved in a problem of art—in the manipulation of space and of material—to reach an acceptable formal unity. In making a painting, artists have endless concerns exclusive of the phenomenal or real world, concerns having to do with formality.

Painters then, may create while expressing their response to the real world, may develop a solution to a problem in form, or may do both at the same time. A picture, descriptive or abstract, must have formal attributes; otherwise it will never meet definition as a painting.

Paintings exist by reason of the fact that we humans empathize emotionally with form. Willy-nilly painters create imagery to shape viewer reaction. These are reactions not only to the aesthetic element in works of art—responses to the quality of presence in form—but they are responses to the erotic, pantheistic, or other associations stimulated by the work.

An intelligent viewer responds to a painting while mindful of its place in that scheme of forms we call art history. An informed viewer senses the

formal problem while recognizing the painter's solution. Such a viewer empathizes with the painter's world.

Mark Rothko, the viewer concludes, emptied his art of descriptive form. Rothko seems to tell us that the visible world is not worthy of his interest. His middle period works, following a surreal period, offer us escape into a nonarticulated but idyllic experience, while his final paintings are heavy with somber hue reflecting his cast of mind as he contemplated what we call life. To reflect this tragic view, Rothko, the technician, made all effort to intensify, to saturate, to make dense surfaces projections of his spirit.

Jackson Pollock—that dervish of a painter—threw paint, slung paint, made tracks of gestures. Gestures! Gestures are all we have left, he seems to tell us, so robbed are we of humanity in these present times. Strange that so hopeless an ambition could make an art so stimulating with means so easy; so easy that anyone able to swing a brush can create an approximation of a Pollock. A democratic style then? Not at all. Only Pollock has made a Pollock!

Willem de Kooning is a person at odds with himself and his intent (or so it is said) and yet ambitious to do the impossible as a painter: To put everything upon a canvas—all of art history, all of our times—as busy as a garbage man stuffing a dumpster as he has earned fame as a leading American painter of the post-World War II years.

Aestheticians have been prating for years that art is order created out of chaos. What are we going to do about an artist who says there is order in chaos? Disorder has an order of its very own; the world is full of a number of things, and this jumble has its own sense. Mr. de Kooning does nothing less than prove this to us.

And so Willem de Kooning comments on inner and outer worlds while exploring the formality latent in ambiguous forms, interchanges of shapes, and nonenvironmental figuration. A doubting fellow with the temerity to be ambitious.

9.

The Painter's Subject

The painter's subject is a matter of pictorial equivalents: The formal equivalent of booming sound in Arthur Dove's *Foghorns* and the formal equivalent of wind in Charles Burchfield's *The Night Wind.*

The subject follows the formal equivalent. The subject of Francis Bacon's *Lying Figure with Hypodermic Needle* is trauma, that moment of desperation when the terrifying reality of our human predicament is pressed in upon us! Bacon has found a form for trauma, for an extremity of anguish. His depiction of the human figure and of the needle is a necessary form equivalent, a correspondence with life experience. Description becomes a necessity. We stand before the Bacon sensing that its form is right. We all have known trauma, and in the painting of Bacon we reexperience trauma. He has found the form of a truth.

Why is it that direct representations of natural scenes, which would seem to be an equivalent in art of life, can fail to move us as truth?

I am looking at a reproduction of a landscape. To quote the caption, ". . . we see a group at work and at play by the placid waters of an inlet, painted in brilliant blues and greens by the artist, while on either shore rise high colorful cliffs piercing a sullen sky. The handling of the water and its reflections is interesting as is the warm painting of the foreground." The panel is organized, "composed" as art academicians would say. The panel is disposed formally enough to achieve a unity. What, then, is the

17

difficulty? The trouble is that its creator has attempted to transfer life to canvas and has failed to translate the experience represented into a formal invention constituting the experience, some equivalent in form. Invention must be formal, as Dove's soft circles are expressive of sound waves, or based upon keen observation and reduction through generalization of descriptive form, as in Edward Hopper. The subject of Edward Hopper's work is loneliness; the subject of Morris Grave's *Bird Singing in the Moonlight* has to do with enduring human spirit; the subject of Ivan Albright is human vicissitude. Each of these painters paints other than appearances. They have invented an equivalent—the subject, which arouses consequent viewer emotion.

The subject cannot be painted straight away. One cannot paint loneliness, vicissitude, trauma, or spiritual endurance. The subject follows engagement with a problem in form. To be sure, form dealt with for purely plastic or optical purposes sometimes conveys existential or some other philosophical overtone as supplied by the viewer. Bacon's task has to do with conceptualizing a moving, writhing figure as form. He does know of the painting's eventual subject (he, too, has been there before), yet even so, his problem lies with making an equivalent form. He identifies with objects and events in life but wishes to concretize these as form.

And this is why life has not been confused with art, albeit derived from form in life. The subject was created when form in life was cast into a corresponding referential form in art, at which point it became other than form in life: It becomes form in paint.

Conversely, the landscape artist sought only to transfer something of the world to his canvas. He confused life with art, thinking them the same. While dreaming to fashion art, he really dreamt of life.

10.

The Art Scene and Allied Matters

The art scene today is remarkably permissive. Myriads of forms in an extraordinary variety of materials fill viewing spaces. Gaps between the media have disappeared. A painting may look in part like sculpture. Sculpture is painted. Prints project areas in relief. Photography presents images of dramatic intensity competitive with other visual formats. Ceramics range from delicate vases to sculptural monumentality. The cultural explosion may not be real, but there is no doubt that an explosion in art forms is occurring.

A student (clever chap) turned in several projects to be graded in a drawing course. He turned in the same projects to be graded in photography and painting courses. He received a grade of "A" in each course, for his items were drawing, were photography, and were painting—formally, expressively, and technically—there was no doubt that his submissions fell under each category.

The Western tradition of art has used the nature of the medium to categorize its visual art: One drew in pencil, graphite, chalk, bistre, or crayon; one painted in oil, tempera, or watercolor. One sculpted in stone or clay.

Rauschenberg and Rivers to one side, for the most part abstract-expressionism represented a state of innocence. It was a pure act. Abstract-expression was painting. Read Clement Greenberg on Jackson Pollock, read Thomas Hess or Harold Rosenburg on de Kooning. The champions of abstract-expressionism were noisy about this.

While abstract–expressionistic art was full of ambiguous allusion to the visual world, all agreed that one fact existed above all other facts: the larger meaning was the painted fact of the picture—the gesture with paint, paint as paint—and heaven preserve the painter if the picture had description dominating the paint itself.

I changed from abstract–expressionism early in my career to figurative images. It was a distressing period for me, because I did this when painters, critics, art editors, and museum directors were parochial about the movement. Art cognoscenti agreed almost to a man that the "figure is dead!" We handful of figurative painters felt like traitors. I felt so traitorous that I vacillated between more-or-less abstract painting and figurative painting for six years.

One late afternoon I had completed the sixth of a series of overhead figures. I phoned a painter acquaintance and invited him to view them. He appeared, commented on a couple of nice passages that struck him as exceptional, and went away. I hauled all six to an incinerator and set a match to them. The next day I was told by Luis Eades that he had been impressed but had not known what to say. I repainted the images as well as I could remember them.

That period was out of sympathy with what I did. In fact, the times dictated that I should not be doing what I was doing. To be honest, if I'd had an original idea that would have netted me good abstract–expressionistic paintings, I would not have been fiddling with the figure. I learned that it is damned hard to buck the artistic trend of the hour.

At any time the world is full of stuff to be imaged as images expressing the times, but time as composed of natural and human event does not prescribe art form. Art does this. The unfolding of its form brings shape to the day. There is a logical language in art. Cubism prescribed Mondrian, for instance. A period of hard or hard-edge form will be followed by a period of soft and soft-edge form, as night follows day—as action and reaction.

What the majority of artists are doing at any given time will seem the rightest. At times an agreement of dealers, collectors, and critics determines a favored artist's direction. Fame and fortune appear to stalk painters, who, if they are wise, will not believe their publicity.

Artists join movements for there is safety in an art movement. To be where the scene is, is to be where emotional security lies. But movements pose a problem for that artist who wishes to remain individual. How does one craft viable art from outside art's main stream? Should one?

Surely it is obvious that various movements come and go. In recent decades we have had pop and op, hard-edge, minimal, funk, earth, body, concept and nonconcept art all paraded before us—movements ad nauseum. And then there's video art and photo–realism. And others.

I parody François Villon, the fifteenth-century French poet:

> Tell me what has happened to the movements?
> Where is the regionalism of America First?
> Where is ab–ex once thought eternal?
> Art to last one thousand years!
>
> Where is Joan Mitchell, and where is Resnick?
> Each of them the greatest artist!
> Where is West Coast figurative art?
> Where is funk? Where did it go?
> But tell me true, before you leave me:
> *Where are the movements of yester year?*

It is worth noting that the germinal idea for each movement originated with one person. Now and again several artists unknown to one another happen to express ideas having common qualities. This phenomenon is a response to "period vision," each artist having seen and felt identically. I am struck by the apparent inability of hundreds of painters during the 1950s to detect that they were doing no more or less than exploiting de Kooning's personal style. Op artists made variations of Vasarely's work and that of Richard Anuszkiewicz. God alone knows what their followers are doing today.

Do you recall a de Kooning exhibition at Knoedler Gallery and the savagely critical reaction of the press? What a disappointing show, etc., etc. He had not changed. He had not improved, they whinnied. None seemed to understand that de Kooning's business is to paint de Koonings. His business is to work out his system; it should have never been any other painter's business. What the press overlooked was that for more than ten years hundreds, if not thousands, of painters were using the man's style. Quite naturally this massive exploitation of de Kooning sapped freshness from the effectiveness of his imagery.

Art publicists seize an artist; Presently art circles and art departments are bombarded with an artist's name. A movement then springs into being. More critics and more artists jump on the bandwagon. A fever spreads across the land. Sweet little old ladies stop painting sunsets and try their hand at trend art.

There is no sense in this except that exploitation of artists in a movement does fill some coffers, and some dealers and some collectors get richer.

11.

Propitious Times

As cubist painting became evermore nonrepresentational, Georges Braque introduced material other than pigment into the picture. Hans Arp presently adhered projecting pieces of wood to picture surfaces. Dadaists used "found objects." Constructivists projected their paintings from the wall; some constructions left the wall to become freestanding. Between World Wars I and II, art activity continued within the framework of categories for the most part. New categories were added, named for techniques such as frottage and d'coupage.

Following the second war, Robert Rauschenberg stole a march on Kurt Schwitters by coining the term "combine painting:" Ab–ex panels hung with pillows and other objects. Jasper Johns followed while paying homage to Duchamp, Oldenburg, Rosenquist, and Wesselman. Others introduced three-dimensional elements into their works using the new materials such as epoxys and polyesters.

Categories disappeared.

It seems to me that with the disappearance of category came dangers. Too much freedom in the arts is as bad as no freedom at all. It takes real artistic character for artists to limit themselves. The parameters of freedom are established by the painter's idea or ideas. It takes grit to hang to an idea.

Ideas differ in their possibilities. Rothko arrived at an extremely limiting idea, one seemingly having limited latitude for exploitation. We know,

however, how deeply he probed. Jackson Pollock pushed drip painting to its furthest possibility, so completely that eventually his work was in real trouble, in a cul-de-sac so to speak. It had no place to go.

On the other hand, Rauschenberg opened up large territories to be explored. So did Claes Oldenburg with his "soft" objects and gigantism of objects as ideas. Fortunate artists, both. Their good luck was to have come upon relatively unused ideas permissive of generous latitudes for play.

Much of today's art has settled at an existential level recognizing the temporary nature of everything animate and inanimate. Some have arrived at throw-away art, art for the hour, novelties created for the moment. Some attempt to make their lives art by practicing arty activities while keeping zany records to be displayed or published. It is true that the practice of democracy permits poseurs to call themselves artists. Who can deny them? Well, I can, for one!

I can, for I am confident that a certain measure of information and a measure of application is necessary before good art can be made. Those who think they become artists by simply hanging their shingle before a loft strike me as simple-minded.

One views the paintings of Edward Hopper and learns how weighty, how solid, a painting can be. One views the painting of Edwin Dickinson to know painting can be visual poetry. One peers into the boxes of Joseph Corneill and knows better than to try to match that sensitivity. How many match the precision of Ellsworth Kelly? The geometric dazzle of Anuszkiewicz? The complexity of Richard Lindner? The pastoral expressiveness of Charles Burchfield? Each has his own view of life, and of art. Each has painted an oeuvre that reflects this. Each dug one from the veins of his ideas.

One of the reasons certain artists have followers is that their work takes on a "look." The look of a picture is the sum total of what a painter has put upon a surface in the way of marks and shapes. This is what the follower steals. The original idea, had inherent in it a question of the outcome, the answer. The follower repeats the look without having asked the question.

12.
Style

A number of years ago I wrote and illustrated a manuscript for what was to be a book revolutionizing man's view of painting. I would, like Dali, reveal secrets hitherto hidden from lay eyes and from the eyes of many who pursued art in professional ways. I would reveal all, and this would reveal me as the one person in history who truly understood art. I had in my possession an idea that, by application to styles in painting, would explain their essence. I called my book-to-be *Keys to Style in Painting*.

Style as the final denominator, I reasoned, is the look of a picture. Painters must do something with their mediums, something with their brushes. That something, I planned to explain, consists of some kind of shape and texture and stroke, some kind of individual behavior of line. The stroke might be broad, narrow, long, short, unvaried or varied, dot, dash, clean, or furred. The line might be thick, thin, light, heavy, continuous, or discontinuous. *Keys to Style in Painting* would take all of this into account.

To prove my thesis I sorted out certain of the major stylists: El Greco, Van Gogh, Rubens, Brueghel, Rowlandson, Moore, Daumier, Thomas Hart Benton, Kuniyoshi, and others. I chose to invent the mask of an elderly male to whose contour and features I would apply the "key" in question. Drawing the figure while using angular strokes led to the elongation of El Greco. By drawing the figure using a series of short connected double semicircles, I created Rowlandson–like images. I drew the figure using short convul-

sive lines and Daumier-like images resulted. Van Gogh was easy; dots, rows of parallel marks, and rows of convulsive marks did the trick. And so it went.

It was in business as a kind of visual detective. I completed my project during the Christmas holidays and showed my results to friends. They were ecstatic. It seemed that they had not understood art until now. One pal at once planned a movie that would have me illustrate my thesis for a multitudinous audience wishing to know (but thwarted from obtaining) the secrets of art.

For myself, I was rather taken in by what I had done. But alas, I began to hold reservations that became increasingly clear to me. Eventually I realized that, while I had pointed out the conscious or unconscious handwriting employed in the stylistic formation of certain painted images, the expressive measures peculiar to painting were being ignored. I dropped my project with regret.

What is important about Van Gogh is the world of vision he set before us. So it was with Domenico Theotocopuli and with Rowlandson. As we are moved to emotion by their apparitions, we are moved toward the experience of art. A painted image can, of course, be successfully founded upon an idea that has aspects of a gimmick. Malevich's white-on-white is not more technically, yet the emotional yield gave society the experience of "nonobject." Planting a coke bottle before a red canvas or hanging a coat hanger before a black canvas are gimmick-like, yet those actions yield emotion.

The painter accused of using a gimmick does more than that anyway. Art work is always expressive of an attitude, of a position in art, or of a relationship with an environment the painter sees as organic, geometric, or as object, as dream, play or memory. The painter's sources for imagery come from everywhere, from inside and from outside.

I think of what happens to dogs as represented by painters. Remember a Dubuffet drawing of a dog? Its flattened outline and body studded with pebble-like dots and nuggets—a dog smacked flat against asphalt; and the dog drawn with a multitude of quivering contours—a dog shaking its body free of water. Do you remember the dog-like shapes of Baziotes? A dog, or similar animal, running his many legs. And then there are the dogs of Francis Bacon, tottering away from the scene of encounter with a fast-moving vehicle or exhausted after an extended run. In these instances, the painter has encountered real life experiences and has possessed the imagination to formulate observations as art. Did their formal equipment cause their encounters to register meaningfully, or did they have the encounter and then invent or discover the formal equipment?

Here is the answer: Painters must view experience conceptually and cast certain experiences into the mode of their personalized forms. We painters see in environment that form that is best adaptable to our own formal concepts which are conceived *a priori* to our encounters with the

real world. To be sure, from time to time we see form possibilities that might literally be abstracted from the real world, but we ignore them. We accept only that which will further the unfolding formal patterns with which we are engaged even though we are not necessarily preoccupied to the exclusion of all else. We are busy shaping the real. Or, to put another way, we painters make forms—with all their illusions and allusions—that will convince us of their being, of their presence as truth. We are required to develop shapes that behave—no, more than that—belong together. These must relate in a fresh way, in so far as we can manage, and they have not as yet appeared in art history. We create a new context of form, or isolate a form, so that we reach the level of new vision, our truth in form.

Mannerism, stylization, pastiche, mere style cannot do this, cannot make us exclaim of a revelation, of an insight into art, or of fresh insight into the phenomenal world. The viewer, then, must be acquainted with the various in painting to obtain the satisfaction of recognizing the latest in serious art. An interest applied over time will eventually teach recognition of the spurious, the specious, the mannered and ill-conceived, to differentiate between the original and the unoriginal, to spot, in short, the difference between imitative art and nonimitative art. It is more important to feel a vision expressed than to recognize marks of the stylist; the one is easy, the other harder to do.

13.
What Shaped Today's Paintings

There is a price to pay to become good painters, for there are fundamentals. I mean by this that we should have sound courses in anatomy. We should have studied life drawing and painting. We should have sound schooling in perspective. We should explore methods and materials. We should learn of color and design. We should have extensive grounding in art history and, in particular, thorough exposure to the ideas behind major movements and to the motivating ideas of leading twentieth-century painters.

The next few pages speak of one view—my view—of what shaped our present era of painting.

Webster's Seventh New Collegiate Dictionary defines plane as "a surface of such nature that a straight line joining two of its points lies wholly in the surface; a flat or level surface; a level of existence, consciousness, or development."

One time I found a book purporting to explain something called "modern art." I was all agog for, while inhibited by conservative teaching, I was young enough to wish to explore. Almost at once the author began to talk about something known as the picture plane. Furthermore, the author marveled at the way in which a certain shape in a certain painting by Miro laid on, or flush, to the picture plane. I could not see what was meant. I visited the A.E. Gallatin Collection at the Philadelphia Museum of Art until I understood.

No sooner does one understand that there is something known as a "picture plane" than one learns that there is something known as "space." I knew that distance and interval between things in the visual world were explained by means of the laws of perspective. I knew that scale relationships of things in the visual world were explained by means of the laws of perspective, but because of the new concept, images abiding by these laws were meaningless. Perspective had become antique, only fit for the usage of antiquarians. A Rubens could be explained by the contemporary spatial laws; even a Rembrandt could. The word "space," and what it meant, was all-pervasive, ubiquitous. I read that the pictures of Rembrandt could be read less the descriptive imagery; indeed, that the imagery hindered the spatial reading of Rembrandt. I read that a Rembrandt could be a Rembrandt without all of that humanistic drivel. I read that art was of necessity abstract and that what artists did was create "orders" in space. "What are you doing, Artist?" "I am creating a new order in space." "Oh!" Eventually, Jack Levine called these painters "space cadets."

Sometime following the burst of attention given to the "drip" painting of Jackson Pollock, I learned that we had moved into the era of "infinite planes" as opposed to the finite, window view, that had been pictorial space since the Renaissance. The new concept (new to me, anyway) had it that a painting should now be painted in the theoretical knowledge that it extended on and on to encircle the globe or to extend upward into the regions of quasars, galaxies, and black holes (those spaces in the heavens so loaded with gravity that light itself is trapped, never to escape in all eternity).

Pretty deep stuff, that infinite space!

Someone wrote an article somewhere to explain the space of Rauschenberg. It seems that to understand Rauschenberg's art one must appreciate that it is accomplished by approaching the picture plane as though it were a flat horizontal surface.

The only remark of Robert Rauschenberg's that I have encountered and remembered, quoted him as saying that his rule of composition was not to place any shape—any positive shape—at the center of the picture.

I began to understand that the picture, or "primary" plane, was whatever we made it in theory and that the theory determined what happened on it visually, but I also began to feel that, whatever the conceptual approach to it, the original concept as manifest in the physical object remained inviolate: That original concept was that the plane is flat and two-dimensional, and I began to see that here was the constant factor in contemporary easel painting, a reference, a mighty useful convention. I began to see that the experienced or trained eye will make reference to that "constant factor" that is carried in one's mind whenever looking at a painting, or for that matter, other works of art, such as sculpture. (It takes no mental effort to relate the imagery of Segal or Gallo to the plane, whereas it is impossible to relate Henry Moore's hulks to the plane.)

With the experiments of the cubists arose questions about "what is a painting?" To this day Jasper Johns contends that he is asking "what is a painting?" So are we all. Well, with the cubists came the notion that a painting was a surface. Thomas Hess once gravely wrote that cubist painting had six inches of depth in the play of shapes across the surface. He had measured it with a plumb bob.

The post-cubist painting of Georges Braque was frequently—to my mind, at least—almost travesty upon the synthetic cubist emphasis upon surface. Braque, late in his career, troweled on paint in gobs as though he were frosting a cake or had gone mad squeezing the contents from pound tubes of toothpaste. If one looked with one eye closed, a duck or a member of the goose family could be seen streaking northward through piles of goop.

At any rate, debates began to rage in art circles about whether any illusion was allowable in picture-making. Figurative painting, which was most times in all or some degree illusionistic, began to fall upon evil days. It was not honest. Illusionism was not compatible to the plane. The only honesty was with the maker of the autonomous painting. The only honesty was with the maker of paintings as objects. The painting must be its own subject. (I remind you that in some quarters this opinion continues, perhaps with the difference that some now accept illusionism in the painting as object.)

Paul Cézanne said, "The contour eludes me." Cézanne in his day and long after was thought to be a clumsy painter. He was called "the great amateur." It seems the poor fellow could not draw. Witness the several attempts to pin down the outlines of the figures in his pictorial schemes. The trouble was that his strategy was not visible to either his peers or his critics. Cézanne could and did on occasion whip out a line as calculated and as accurate as a Walt Disney animator. Cézanne had sensed that the illusion of objects, which are three-dimensional, transposed to a two-dimensional surface denies the reality of that surface.

Objects seen in the phenomenal world repose or move against a background; transposed to a surface, that surface is demolished as the illusion of object against background is painted. The crisis of contemporary art had appeared; the critical point had been reached. What to do about it?

Western artists, including Cézanne, were emotionally locked into the idea that the pictorial arts were subscriptive to programs relating to the depiction of some aspect of nature. Our experience of the world was the thing, not necessarily our experience of art.

One can imagine Cézanne moving from painting to painting, solving his problems. The repeated contours were his strategy to bridge the contact of two shapes. It was here that paintings fell apart, where figures met the "ground." It was easy for him to facet rocks, foliage, earth, buildings, water, and figures into planes built of brushmarks. It was easy, for all of these were solid objects. But the sky, the sky full of puffy clouds, of vapor-

ous intangible substance, eluded him. He could not think of air and sky and cloud as tangible enough to facet as objects, and it was not until the end, until his very late painting, that we find that he treated the heavenly elements in the same way as the earthly. The man who had said that his father, the miller, was a genius, for he had willed him money, had precipitated the revolution now labeled Modern Art.

In addition, Cézanne had the instinct for making marks that were "planar" in character, making each a microscopic reference to the macrocosmic fact of the picture plane itself.

The cubists faceted the object and lost its image and in doing so converted background into shape. I don't know when the terms "figure–ground" or "positive–negative" were first used, or who first defined them to explain the positioning of shapes in a painting. I do know that these are useful terms with which we may discuss painting and that to understand the role played by the recognition of the negative as shape is to understand much of twentieth-century art. (The less experienced Fairfield Porter was advised by the experienced Willem de Kooning to emphasize the negative. With that knowledge Porter made a substantial contribution to figurative art.)

With the cubists' discoveries, with the later pictorial essays of Pablo Ruiz Picasso, with the efforts of Mondrian and Malevich, and of others, the formal aspects of painting began to open up to possibilities unknown when painting had been confined to depiction of figure in environment. Meantime, of course, the expressionists were going their diverse ways; some, like Max Beckman, using the new sensibility for measuring his image against the plane as others created mad "impastos," wild attempts to embalm their visceral feelings in lards of paint.

The surrealists were pursuing their courses. The pornographer, Juan Miro, was much respected, for he paid homage to the plane, while Dali was despised in quarters for his oblivion to what had become sanctified in art, the picture plane.

The dadaists had made "anti-art," which subscribed to the new tenants of art and therefore subverted their announced intent. One, Hans Arp, threw biomorphic shapes onto surfaces and announced that every arrangement was as good as every other arrangement. Picasso and Duchamp "found objects," bicycle wheels, handlebars, and urinals, and said these were art, if considered art.

And it was true. Yet the question continues to be asked: What is art? What is painting? The question continues to be asked, for it is the only way in which art, or painting, can continue to be made. In the solutions there are no final answers to the question, but more art. As long as the question continues to be asked, painted art will be made.

Long live the question!

The picture, or primary plane, lies on a surface. To maintain the in-

tegrity of this surface has been at the very core of answers to the question. Many are haunted by the need.

Dubuffet speaks of the wrenches he experiences, his desire for form and his equal desire toward formlessness. This formlessness is seen in his "texturologies" and "soils," which lie in plastic densities across the plane. Form is seen in his *Corp de Dames,* which are heaped with rubble extending through both figure and ground in desperate effort to maintain the plane.

Many of us are involved with "tension" as was Cézanne—the tension between form and formlessness. Olitski paints huge "field" paintings, testaments to the plane, but places strokes of paint along the peripheral edges of the canvas (to reinforce the formless surface, or as a tentative grasp toward forming the surface, or something else?).

Barnett Newman introduced the verticle line to acquaint us with the "verticality" of the plane. He took risk when he molested the plane so little, for he was the first to do it. In introducing the figure, that is the stripes, he revealed the ground. A perfect solution to the figure–ground problem. Rauschenberg and Ellsworth Kelly have also found perfect solutions to the figure–ground problem by painting the entire surface of the canvas, thus making the ground the figure. Another solution is to simply strip the canvas edges.

Albers, of course, by painting a square atop a square atop a plane was repeating the primary plane, again a solution to the figure–ground problem. Helen Frankenthaller washes her canvases with pigment. The fiber absorbs the wash to create unified surfaces, another solution to the figure–ground problem.

Perhaps you will carp because I haven't mentioned color as used by these painters. I am speaking of the "formal" vehicles of their color.

Jasper Johns painted a flag of paper collage and encaustic, a perfect solution. He eliminated ground entirely (but sadly, he had returned to description). Frank Stella painted a nonfigurative image sans ground and was hailed as a great artist. The nonfigure was all figure, entirely planar, a perfect figure–ground solution.

Warhol silkscreened a field of coke bottles. The images, row upon row, maintain tension across the field and in effect become all ground. He screened Marilyn Monroe's features against a background, and only by use of intense color, equally distributed, could he save himself from the accusation of being retrograde, or of returning to the traditional figure-in-environment image.

As I teach, I speak of families of shapes, holding shapes, of curved or warped planes, of thrusts, of congestions, of modulation, of tension, of penetration and interpenetration, of fractures, of shifts, of heroes, containers, events, systems, of points and other matters, references for what happens or can happen on the plane.

I find the idea of "points" most useful. I think that I first became aware of this as I looked over some Miro "constellations" years ago—fields of various shaped points—like the milky way of stars, but black or colored, rather than white and glittery.

Points are areas of emphasis that cause the viewer's eye to regard the tautness of the plane stretched through the image. Points help to pin the image down into a formal posture, into an unmoving disposition that is its unity; for to be formal a painted image must not move. It must be fixed to the plane somehow, even though it images movement descriptively or abstractly. To be formal, with whatever illusion, reference to the plane must be implied.

And, thank God, there assuredly are, as there have been, endless solutions yielding unities; context to be discovered, strange collaborations of shapes to be made, imaginative leaps to be made, that will yield new emotion in the viewer, that emotion as old as those experienced twenty thousand years ago at Altamira and before, and as new as tomorrow.

Whatever your concept of it, the plane will be there as it has been supporting, even shaping those apparitions, those forms and nonforms that limn our hopes and dreams, sorrows and tragedies. Those marvels of contrivance created rationally and/or irrationally that we call art.

Perhaps it is a mistake for me to go on, following such an impassioned paragraph, but I am inclined as an art teacher to wish to give you some practical benefits for your work, to give you something that you can apply at once. Ask questions, then, I say. If I were you, I'd examine what has happened in art, as well as what is happening in art. I might ask questions that have been asked before but I would devise my own answers.

14.

The Baffling Picture

An illustration, such as those used to embellish stories in magazines, is purposefully story-telling. Much so-called "fine" art is also story-telling. What then is the difference?

The difference is seen in the organization of the one compared to the other. The figures, furniture, and so on in illustration can be shifted about without really harming organization. Indeed, it is the purpose of illustrators to make their theme appear real in the real-life sense that we encounter things in the objective world where images move—where figures get up from chairs, move across a room, and so on. The formally composed work of fine art is organized so that none of its parts can be changed; shifting any part of the composition would do irreparable harm.

Painters regularly have the experience of bringing a picture to completion without recognition of its completion. Upon introduction of another color, passage, or shape—upon the introduction of some element not already employed—they find that the painting must be repainted to incorporate the new element to fulfill a new unity. As a matter of fact, a new element introduced into the pictorial scheme may lead to entire systems of changes.

An important characteristic of a painting is that it cannot be understood in all of its parts by a viewer. We have described wherein a painting differs from an illustration, and now we note wherein the painting differs from a diagram. A diagram can be understood in its entirety. That is its

very purpose. A painting cannot be understood, for artists build into pictures elements that are in their very purpose baffling. How do they do this? What do they do? Well, if the artists are Jackson Pollocks they create a complex field of lines that weaves layers of shapes over other layers in such profusion and density no viewer will ever be able to unravel them. If the artists are Rembrandt they take care to lose part of the contour of a hat or cape in shadow. Viewers can stand before such a painting until Doomsday and be unable to locate accurately the contours. Look at good paintings and you will always find what we might call "baffles." Look at a late Mondrian. A diagram? Not at all, for you will find each line is a different width and you will not be able to predict the width of a line before you come to it. Scan the painting and you will find you have lost the measurement of a measured line by the time you return to it. Does Joseph Albers make diagrams? Look at the edges of his seemingly simple squares and you will find each edge differs in its slant. And Rothko? Notice the function of his blurred and ragged edges. The planes seem to hover and no one can tie them down to the periphery of the painting. The planes come out to the viewer and then recede. Where exactly are they?

You will find paintings that are planar and contain large areas painted with even distributions of paint over their surfaces. On the other hand, you will find paintings with their surfaces filled with a multitude of brush strokes, all of them visible. Nathan Oliveira paints pictures in the planar category. Wolf Kahn paints pictures in the second category. Resnick moved from the influence of de Kooning, who paints with an emphasis upon planar behavior, into the second category where his brush work resembles Monet's. I believe you have a choice of direction in this regard. The choice you make will be decided as you find your intentions.

15.
The Objective Correlative and Resonance

Some time ago I came to the conclusion that I wished to paint in the figurative rather than in the abstract tradition. Others have rejected abstraction as a mode for their own painting. Why is this? Undeniably, some painters find subject matter is necessary because of their need to identify with time-proven tradition. Artists might paint flowers because of their admiration for Degas or Van Gogh. But there is more to it than this. Subject has its uses. You and I live our lives out among things like tables, chairs, trees, and mountains. Any *thing* can be the painter's subject. Since viewers live out their lives among things, it follows that the viewer can relate to an image of a thing as seen in a painting. The viewers' experiences have made them familiar with the subject matter of the picture, and, while the viewers have experienced the thing depicted in a variety of ways different from other viewers, viewers can agree upon the subject as a common denominator in their experience.

A thing is always symbolic, which means that while an object exists in our environment as a thing, it is seen conceptually by anyone who looks at it. One commonly accepted concept is that apples are red. When Matisse painted the image of an apple in tones of magenta, he gave the viewer a point of reference, the apple-shaped image. The viewer holds the conception that apples are red. Viewers are brought to a vivid realization of what Matisse has done with color because of the difference between their concept of apples as red apples and Matisse's revelation that apples can be

conceived as tones of magenta. The trick for Matisse was to paint the image with such authority that the viewer is made to believe apples *can* be colored magenta. In fact, Matisse may convince the viewers forevermore that apples are in reality magenta in color. In this event Matisse, through the power of his painting, has been responsible for changing the viewers' concept of apples.

Used by themselves, the elements of art have emotive force, but what painters do to the subject matter in their pictures can have emotive force also.

The late Paul Nash, British artist of the twentieth century, once painted a landscape in which the shapes indicate that he was referring to corn shocks, rows of trees, hills, and several fields. Nash fashioned shapes with hard, tight edges that referred to nature. The presence of *shape* became in his picture something more pronounced than images with an immediate reference to appearance in nature. While the interest of the artists was in the formal elements of painting (line, form, hue, and so forth), interest is revealed, and emotive force is generated out of the viewers' sense of the actuality of the scene as contracted with the actuality of the picture.

It might be profitable to turn to an art other than painting so that we may clarify reasons for using subject matter. Let's examine a fragment from T.S. Eliot's *The Hollow Men* after I first explain a term Eliot has coined. The term is "objective correlative." The images in Eliot's poems that refer to objects in the real world he calls "objective correlatives." References to what Eliot assumes to be within the reader's experience also are "objective correlatives." The poem goes like this:

> Here we go round the prickly pear
> Prickly pear prickly pear
> Here we go round the prickly pear
> At five o'clock in the morning.

First of all, we identify immediately with an "objective correlative" which follows the nursery rhyme:

> Here we go round the mulberry bush,
> The mulberry bush, the mulberry bush,
> Here we go round the mulberry bush,
> So early in the morning.

The first objective correlative is an innocent little jingle. Next, we identify with "prickly pear." We know the prickly pear to be a plant of the cactus family living out its tenacious life in the inhospitable desert. We come to the realization that all humanity is going about a stand of prickly pear. All humanity circling utterly aimlessly at five o'clock in the morning, an hour

when all but the milkman should be in bed. Out of these three images is generated in the reader the aura of feeling that becomes the art of the poem. Meaning turns upon the poet's pessimism. Meaning turns upon the suggestion provided by the objective correlatives which relate in turn to subject matter we knew before we ever knew the poem. So it is with a picture: meaning is generated by what happens through technique to a pictured image that is usually related to an actual object or event to be found in our experience of the real world.

I have frequently puzzled about what to call the happening experienced by viewers as they look at a descriptive picture. Fortunately, an article in a magazine gave me just the term I needed. The article was about the role of the nude in art, but I believe the explanation would apply to any picture using subject matter. Pierre Klossowski called his article *The Falling Nymphs (Portfolio and Art News Annual, No. 3, 1960, p. 130)*, and he explains his use of the word resonance as follows:

> The painted interpretation of the female body stripped naked is accomplished in that space interior to the contemplating eye, where the motif has been grasped, felt, and conceived, where the artist's eye and the spectator's are identified for a moment: the moment of initial emotion. Here the spectator, as in a moment of unconscious recollection, finds the reference to his own reaction in the experience of that Other, the artist—who is the Other *par excellence*—and who by his testimony provides the spectator with the commentary upon a mutual emotion. It is this commentary which creates the *resonance* of a painting and holds us by the duration of this resonance; it is here that that recollection is fulfilled.

Now, we have been considering the subject-oriented painting, but what about the painting that seems to be unrelated to things in the real world? What about abstractions? Are abstractions really unrelated to the real world? Of course not, for they refer to other abstract paintings. It is impossible to look at an abstract picture without making reference to other similar pictures. Before an abstraction viewers recollect other abstractions they have seen, and for this reason they understand the ways in which the abstract they are looking at is singular, and where in it there are elements yielding to them fresh experience.

The principal difference between descriptive painting and abstract painting is that the first can bring the viewer to reexperience things or events outside of art, while the second requires the viewer to reexperience art. I hear you say that you've seen abstractions that seem to refer to something other than art, and I reply that this is often true, but the reference is ambiguous and up to the viewer to supply. The object-oriented painting is bound to be as specific as its subject content. I mention this in the realization that frequently the subject itself can be unspecific in its suggestion, but in general I can say that descriptive painting is likely to be more specific than is abstract painting.

16.
The Picture as a Visual Phenomenon

Thus far I have said little about abstract painting as such. In the next few pages I mean to speak of painting qua painting as well as object-oriented painting. An understanding of abstract painting means an understanding not only of surface and its possibility for extension into depth but also an understanding of tension.

We painters speak of tension when describing certain behavior at the heart of a painting's vitality; the element most responsible for evoking emotions in the members of its audience. But tension is there at the beginning even before paint has been applied.

Viewers confronting blank canvas are placed in a situation of emotional interplay between themselves and that canvas. They are here, the empty surface is there, and emotion of sorts is induced. However, a dot placed anywhere upon that surface establishes the viewers' desire for particularized interplay. The placement of another dot of a different value introduces an illusion of depth as well as interaction between first dot and second. A field of dots establishes a complex even richer for spectator discovery; but, I hasten to add, such a complex is not necessarily more tense. I suspect that everyone's eye-to-eye encounter in everyday life is responsible for the fact that isolation of two dots side by side in any picture field will cause the viewers' glances to focus there at once. It would appear that a lifetime of encountering eyes conditions viewers to any attraction symbolic of eyes. Much naïve, children's, and primitive art promotes strong psy-

chological responses through the exercise of this gambit. The dual confrontation of any shape, such as a pair of vertical planes or two halves of a painting painted as mirror images one of the other, seems to me to be an extension of this phenomenon.

Byzantine art and certain primitive and naive art establish strong tensional responses in the contemplative spectator through their aspect of rigidity. As painted eyes confront spectators, so can a rigid formal arrangement confront viewers. In this case viewers identify with rigidity of image as they have experienced rigidity upon themselves in life. Rigidity and tension are frequently experienced as synonymous events in real life.

The Byzantine period is a far cry in time from Rothko and Albers. But as we experience the phenomenon of "being confronted" in early Christian art, so we experience the same phenomenon in Rothko, or those paintings of Albers that comprise a couple of simple, colored planes painted dead center on the canvas. Tension in Albers is created by the squares' fixed relationship to the perimeter of the picture. Rothko creates tension through an opposite relationship. Soft rectangles float unfixed in relatedness to the perimeter of the painting.

Let us examine at random a few examples of tensional effects to be found in modern painting that are based upon the way in which we experience the real world through the sense of sight. In other words, let us examine tensional manifestations as seen in the descriptive picture.

I choose first Francis Bacon, the British painter, as an obvious example of a descriptive painter drawing upon such phenomena. *Figure in a Landscape,* 1946, represents a grass field under a cliff of chalk, or rock (anyway, a cliff), and a seated figure with what appears to be a machine gun in his lap. The right sleeve has an arm in it, but the coat is empty. There is no body in the coat, nor is there a head above it. Another painting holds the blurred image of a screaming, or barking, baboon with a cage drawn so that it is read both as exterior and interior. (Is the baboon, a fierce brute, free or a prisoner?) *Dog,* 1952, is another blurred image: In this cage, a dog only recently struck by a vehicle, or perhaps in the throes of a last gasp of old age. These images have this in common: They are all cinema-like in their blurred and rapid movement; all are identifiable with a briefly glimpsed occurrence, the kind of thing we pereire from out of the corner of an eye, or that we happen upon with suddenness; and all of these images are identifiable with the macabre and touch that zone of the nameless dread hidden deep in each spectator's psyche. When Bacon writes of his use of a "memory trace,"* he admits to his game, which is to establish tension between the viewer and his painting by a reference to a community of common experiences that create tension as they are reexperienced by the viewer through the medium of the paintings.

*Andrew C. Ritchie (ed.), *The New Decade: 22 European Painters and Sculptors* (New York: The Museum of Modern Art, 1955), p 63.

Another descriptive painter, Ben Shahn, created figurative presence by manipulating appearances relative to what we see in the real world. For instance, one of his pictures shows a speaker upon a platform that has been set in a field. The platform appears to be in the middle distance of the painting. Everything in the picture is in perspective and in scale with the exception of the upper half of the figure, which appears to be much closer than true perspective and foreshortening would permit it to appear in real life. Tension is created through this paradox, this misconstruction of the appearance we usually accept as actual fact. Shahn has also frequently placed figures at an angle. We understand that these figures are to be read as vertical bodies, and we feel tension because these images defy gravity. Their cant suggests they must fall; the painted postures state these are figures walking upright. The impossible is happening before our eyes, and we feel emotion because of an irreconcilable event. Giacometti, when painting a seated figure, reverses Shahn's manipulation. The image is read as a normally proportioned figure close to us, but its head is small and is seen as farther away from us than its body. The concentration of the head against the body's bulk is enormous. In this impossibility, in this abuse of normal-sighted experience, lies its possibility for provoking viewer response.

The erotica of Modigliani is dependent upon reference of painted nude to naked women. Obviously, erotic suggestion is tensional, which brings up this question: What does the sensuality of painted passages have to do with tension? What of phallic symbols? The answer is simply that certain tensions expressing emotion through art are of an erotic order, and there can be no doubt about it. Such sensation can be evoked through sensuous use of material as well as through image.

In general it can be said that when painters handle their mediums and images with authority, selected disproportions of normal images as encountered visually in everyday life will always be fertile areas of emotionally provocative pictorial instances.

A consideration of tensional devices that correspond to behavior in the world of the simpler phenomena of physics leads us at once into the formality of art, that functional area having to do with how a painting behaves as painting.

Some pictorial tensional events comparable to events in simple physics are suggested to the spectator by their equivalence in appearance to tearing, ripping, shattering, separating, breaking, dropping, thrusting, blocking, flowing, floating, splashing, pulling, clustering, grinding, and shifting; to light reflection and refraction, precarious balance, states of equilibrium, protrusion, extrusion, bulge against plane, pulling, stacking, gravity (anti-gravity), and the ideas of orifice, crevice, and interval. Is this painting or is this simple physics?

Areas of experience other than those I've emphasized have fed the

invention of the painted tensional image. Tensional systems are in painting the symbolical counterpart of constellations and of nuclear worlds. Other such systems have their counterparts in grasses, leaf mosses, rock formations, mountains, and caves.

The machine world offers its shapes of wheel, cog, and gear, of piston and pipe; and the community offers its structures, its buildings and planes and towers, its roads and highways. Advance and recession. Overlap and X-ray. Transparency and opacity. The penetrable and the impenetrable.

And then, there is the weather: fog and cloud, rain and snow, the seasons.

Many tensional instances earn their vitality by violating a pattern of expectancy. The design on the right sleeve of a Picasso figure follows a pattern different from that on the left. The mind reels in its attempt to reconcile these two sleeves into an identical pattern.

A curving plane by de Kooning moves under another but emerges at a point not reconcilable with its point of disappearance.

Two planes confront us; the one is slightly the lower of the two. We are at our wit's end attempting to shift the plane back into position.

We are in front of two shapes, or maybe, two configurations; the one appears to lie forward of the other, but no!—it appears the other is forward. Of course, I'm describing a simple positive-negative interchange.

17.
Drawing

Good painters are invariably good draftsmen. I cannot recollect an exception. I speak of drawing from life and phenomena. Drawing surely began with scratches in sand, mud, or clay, or on rock surfaces. It began milleniums ago, when humanity was new. No doubt drawing was practiced before Altamira. We do know that by Aurignacian times, remarkably skilled draftsmen practiced the art.

Ancient Egypt developed a stylized art. The Greeks developed an art of limning to decorate their now famous vases. During the fifteenth, sixteenth, and seventeenth centuries drawing really flourished; the litany of superb draftsmen goes on and on: Botticelli, da Vinci, Raphael, Michelangelo, Durer, Holbein, Rembrandt. I talk only of the Europeans, for it was from them that we inherited the "lost-and-found" line, and it was from them that we learned to depict light falling on volume. This information, plus perspective, gave Western artists the capacity for illusion that has played such a large part in occidental tradition.

Drawing as a medium has its own properties, its own nature. Drawing is in line. The art of drawing has arisen out of a need to describe the edges of things. As drawing becomes mass, it invades the territory of painting. A charcoal drawing in mass can invade the territory of painting just as line in a painting can make a colored drawing of that painting. With line the form of things can be probed in detail for clearer understanding; hence, drawing is basic for the grasp of form in painting, and through draw-

ing we look at nature. Rocks are solids. Sky is vaporous, penetrable. Foliage is penetrable. Earth is solid. Water is fluid. Any area of natural phenomena contains the nucleus of an idea for painting.

Observation of beginning adult artists has convinced me that they naturally draw in outline. They tend to describe an object by contour.

We have been speaking of "contour drawing," and now a word about the most important kind of drawing—the "gesture drawing."

To the uninitiated, gesture drawing looks like what is known in common parlance as "sketching," but such a definition does not do gesture drawing justice. Gesture drawing does look rapid, and it is, but despite the characteristic quickness of gesture, it accounts for proportion, anatomy, and volume when used to describe a figure. For a good gesture to be drawn, the draftsman must have instant perception of the model and a highly refined manual dexterity.

Until the nabis and the fauves, Western drawing kept faith with the lost-and-found line, the "Ingres line," its contour lost as it approached a light source and darkening (found) as it moved away. Cast shadow, umbra and penumbra, and modeling by means of hatching or shading, were the means of description. The nabis and the fauves shunted aside these age-old dicta and began to draw with little regard to qualities of description. Their heavy, sometimes colorful, lines insisted that the viewer look at lines as lines, not as means toward illusion.

Twentieth-century art, then, has inherited linear elements in both drawing and painting that spring from these sources. De Kooning, via Soutine, owes his definition of line to the nabis and the fauves. I owe my use of contour to the earlier occidental tradition.

18.
The Picture Planes

There follows a mix of diagrams and reproductions of art to give a visual dimension to the text.

The vertical and horizontal dimensions of the picture plane form the foundation and reference supporting a painting's formality (Figure 18.1).

Figure 18.1
The Picture Plane

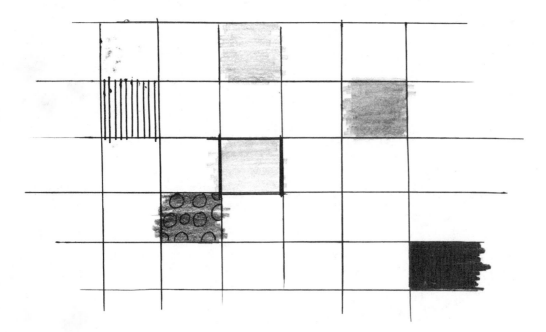

Figure 18.2
The Square or Rectangle

Figure 18.3
Vertical Lines

Figure 18.4
Horizontal Lines

Figure 18.5a
Even Distribution of Paint

Figure 18.5b
Modulated Distribution of Paint

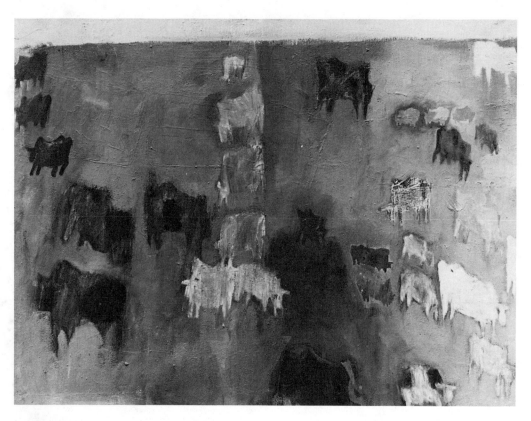

Figure 18.6
MERNET LARSEN
Herd oil, 24" × 36", 1961
Collection of the artist.

Mernet Larsen's image of a herd of cows is an example of points distributed over a field. It is also an example of a "nothing" painting; that is, there is no focus in the format.

Figure 18.7
MERNET LARSEN
Cow at Water oil, 36" × 24", 1961
Collection of the artist.

Ms. Larsen painted a single animal at the center of the field. The viewer's focus would have been riveted upon the point had she not painted a horizon at the top of the picture. At once the viewer's eye plays between the point and the line, a source of tension, as each impinges the viewer's eye with equal emphasis.

Figure 18.8
MERNET LARSEN
Cow at Water oil, 36″ × 36″, 1961
Collection of the artist.

The third painting in the series depicts *Cow at Water*. The cow is crowded between the horizon line and the curve of the hill to create tension.

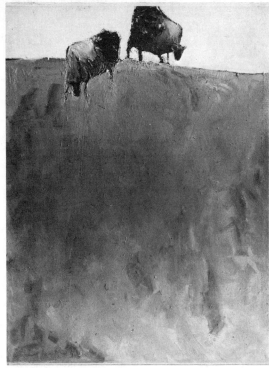

Figure 18.9
MERNET LARSEN'
Two Cows oil, 36″ × 24″, 1961
Collection of the artist.

The fourth painting illustrates "weight" created by two points at the top of the picture. We ordinarily think of weight as being at the bottom of the picture, but, as we see, it can be at the top or elsewhere in the format.

Figure 18.10
MERNET LARSEN
Cows on Hillside oil, 40″ × 36″, 1961
Collection of the artist.

Images create pull from top to bottom, or from bottom to top as created by points. It is obvious by the same means that pull from side to side can be attained. The *Cow Series*, was painted during Ms. Larsen's junior year at the University of Florida—a remarkable performance.

Figure 18.11
Pattern of Expectancy

To illustrate other visual behavior, I have made diagrams using Ms. Larsen's image. I illustrate a "pattern of expectancy" and how it is broken by a variation in the series.

Figure 18.12
The Silhouette.

I illustrate a figure which is positive and the ground (negative) that surrounds it.

Figure 18.13
Figure-Ground Interchange

The viewer's eye picks up one side first, and then the other as figure. Each side becomes ground in turn as the eye switches.

19.

The Picture and "Woman I"

I have already indicated the vast respect I have for the metaphor of Willem de Kooning. This regard grows out of a realization of the enormity of his risk. He has accepted influences right and left but accommodated them so that they have led only to the betterment of his metaphor—its environment, image, and events. Picasso offers the only parallel figure in modern times.

Let us focus upon de Kooning's *Woman I* (Figure 19.1) dated 1950-52, in the collection of the Museum of Modern Art. To understand this painting—to discover its place in the scheme of things—we must go back in time to the paintings of Cézanne. *Woman I* has references to all art history since the "great amateur."

Cézanne painted still life by painting an image related to one view of the setup; and then, after moving his easel to another vantage, painted other positions of the setup to complete the image. Through this method of observation, Cézanne reintroduced an emphasis upon form into painting and into the consciousness of people who concern themselves with art.

Renaissance linear perspective, a codification of special behavior that held Western art enthralled for generations, instructs the artist to place large planes into the foreground of the picture and to decrease other planes in size as they recede into the picture plane. It teaches that large shapes must be in the foreground; that smaller shapes be in the background. It teaches one viewpoint and is a method of attaining an illusion of actual

depth. Aerial perspective furthers the illusion. In effect, a painting becomes a window with its images generally composed to circulate within its borders—the reference of the picture's edges, a "finite plane or space." Cézanne reversed this spatial system and placed small shapes in the foreground and large shapes in the background. This meant an assertion of the flatness of the primary plane; that is, the surface. He composed in such a way that his paintings seemed to be slices out of a larger world. Circumstances introduced the young painters Georges Braque and Pablo Picasso to these monumental works of Cézanne; and in conjunction with Picasso's introduction to African sculpture, cubism came into exsitence.

We must remember that Picasso and Braque were object-oriented emotionally. In the only tradition they really knew, space followed object. Space was around and outside an object. And, at first, they tried only to show more of the object, more points of view of the object, and thereby—theoretically—more reality. Paradoxically, because of the many facets (or views) that were used in their attempt to embody the object into painted image, the object was lost. The cubists had fallen heir to a new kind of space. As their idea developed, new pictorial concepts introduced themselves: overlapping of planes, transparency, multiple image, and positive and negative interchange (where ground can be read as figure, and figure as ground). Yet you can imagine the emotional dissatisfaction felt by these object-oriented young men as they found themselves losing touch with the objective world. It was Braque who came to their rescue by fixing real wallpaper and real newspaper into the painting. This practice came to be known as collage.

Still, direction had been shown toward the autonomous picture. The paintings that were to be as much an object as a chair, a table, or a floor became objects because of their lack of referential image. These paintings became known as "nonobjective" paintings—no object in them—and inexorably, as a result of the logic implicit in the nature of changes in art forms, the exploits of Malevich and Mondrian were introduced into that great collection of art forms that has gathered over time.

A look at *Woman I* shows us the cubist influence—the fractured, shifting planes articulating its space.

More or less contemporary with Cézanne, Paul Gauguin worked in large, flat, freely colored patterns. Contemporary also was Vincent Van Gogh, who painted with short strokes of color, dots, and convulsively curved strokes while trying to express his emotional relationships to the world and to describe the world as an emotional place. Others were affected by this form of vision, in particular a group that came to be known as the *Wild Beasts* (Les Fauves), led by Henri Matisse. In effect, this group sought to liberate line and color. As I said earlier, line by Ingres had been the traditional lost-and-found contour that was used to delineate the edges of objects as drawn from nature. Matisse created contours not only to delineate

the object but so emphasized contour that it was freely expressive of line as line. And the same was done with color. Historically, color had been used to describe hue and value of real surfaces, real volume, and lighting effects. The Fauves used color as color. This approach resulted in the expressionism of the Germans and of expressionists working elsewhere. One of these non-German expressionistic painters was Chaim Soutine. Soutine learned to pile on paint with a kind of vehement savagery, with an exceptional sense of violence for the time; this same kind of violence can be seen in *Woman I*.

Surrealism paralleled the growth of the formally concerned members of the School of Paris and the expressionist group. Surrealism proposes to depict the subliminal depths of men's minds. The Spaniard Dali rather foolishly juxtaposed unlikely descriptive images in unlikely settings. The German Max Ernst made rubbings (or *frottage*, as it came to be called) to implement the creation of a world of queer settings inhabited by queer and fearsome beasts (human beasts, too). The Frenchman Tanguy invented images that had semi-volume and that moved in strongly lighted atmospheres and shadow; in effect, he substituted invented descriptions paralleling description common to representative pictures. Another Spaniard, Joan Miró, invented a universe with inhabitants ranging from simple symbols to images descriptive of the real world. Miró came closest of the Surrealists to inventing truly new images, although shapes float tensionally in most of Miró's universe somewhat parallel to the way shapes are oriented in the universe of Paul Klee.

The Armenian-American Arshile Gorky, much influenced by the cubism of Picasso and the floating forms of Miró, revealed the way to de Kooning. Surrealism pervades *Woman I*.

Another movement other than cubism, expressionism, and surrealism finds its way into *Woman I*—the philosophical slant of the Dadaism of the World War I era. This happens in the following fashion. Dadaism was a movement of philosophical nihilism born as a result of disillusionment felt by certain artists and poets following the catastrophe of the first great modern war. Their art expresses their conclusion that the society of mankind is not good. At the same time the new field of psychology informed Dadaists about a potential for creative results offered through application of the "stream of consciousness" and irrational behavior to creative problems. It was thus that Schwitters made his famous collages from scraps of paper fished from garbage containers.

It should not be surprising that during World War II, New Yorkers were possessed by the same spirit that had inhabited continental metropolitan centers twenty years before. This pessimistic attitude has carried into post-World War II years. The hydrogen and atomic bombs, distress and upheaval of entire populations, the cold war with Russia, the mournful evidences of science, and the general state men find themselves to be

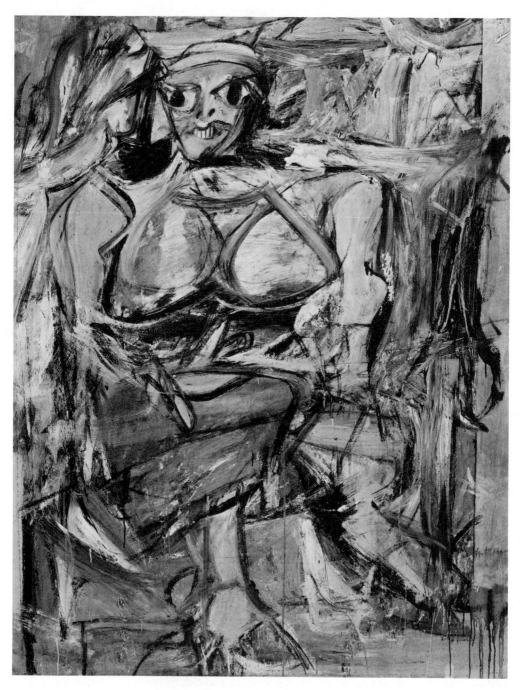

Figure 19.1
WILLEM DE KOONING
Woman I oil, 75⅞" × 58", 1950-52
Collection of the Museum of Modern Art, New York.

Figure 19.2
Interchange of Configurations (1)

The light area in the diagram represents an
assembly of shapes that are read together as
a positive configuration.

Figure 19.3
Interchange of Configurations (2)

The dark area represents the ground to a
positive configuration.

Figure 19.4
Interchange of Configuration (3)

The viewer's eye reads the center of the paint-
ing as a positive configuration.

in have cost us our spiritual security. Intellectuals today tend to find themselves spiritually derelict. This distress informs *Woman I.*

Woman I to an exceptional degree requires a knowledge such as I have outlined before it can be properly appreciated; to a lesser degree, all contemporary painting requires similar knowledge.

Woman I, despite an impossible weight of influence informing the image, has been consolidated into a startlingly original piece. De Kooning has had the integrity and capacity to turn influence to his own ends. It seems to me de Kooning's big new idea was the invention of positive and negative configurations, numbers of shapes that can be read as one, which then interchange as groups of shapes.

A combination of shapes, repeated assemblages of shapes, that can be read as figure and ground over and over, wherever the eye focuses upon the canvas, constitutes one of the major visual vehicles—a vehicle of modern times capable of containing many historical references and a multitude of other meanings. Of course, this ambiguity of forms leads to an ambiguity of image, so that *Woman I* is read as both landscape and figure—a beautiful illustration of the way modern man sees all events as multileveled: that is, as molecular and physical.

20.

About the Picture

Twentieth-century formality is a matter of the functional visual behavior of point and plane. The most important change from traditional practice is the conceptual acceptance of the negative, or ground shapes, in active roles with equal importance to the figurative shapes.

Shapes and marks function to articulate the painting's parts. Some shapes are "holding" shapes and function to remind the viewer of the picture plane. Squares and patches do this. Amorphous shapes when hard-edged may do this. The changing of value from shape to shape can establish push and pull effects. Hue can be modified (reduced) through a mix of black and white, of black or white, or by mixing whatever color is complementary to the hue.

"Long" paint may appear to thrust, to hook out space, to contour. Planes may be graduated, modulated, or shaped to undulate. Strong in-and-out, or undulating, surfaces we speak of as plastic. The behavior of shapes and marks on the picture plane of a given painting we may speak of as its plastique.

When I critique a painting I look toward its corners to find whether or not they have been considered. One cannot, in my estimation, vignette a painting as one can a drawing.

I am opposed to texture for texture's sake. Texture should be whatever surface is created while the painter processes the idea into image.

I choose to divide paintings into those of "confrontation" and those
of "event." Some combine both confrontation and event.

If I stand squarely before you as a painting before a viewer, the expe-
rience is one of confrontation: the experience is directly between us. If I,
as a painting, turn my head, you must optically move in on me. Your eyes
follow my profile as it appears before a background. This I distinguish as
an event. Face one of Alber's paintings of the *Homage to the Square* series.
You will experience confrontation. Face a Pollock at close range and your
eyes must search in and about its maze to assimilate the image, as event.
Figure 20.1 represents a painting of event. The viewer must scan the paint-
ing in order to fund it. A painting, then, can be a picture of confrontation
or event. As we face de Kooning's *Woman I*, the figure (hero) confronts one
but then the painting's parts must be read as figure-ground interchanges,
a combination of event and confrontation.

Figure 20.1
Event

Figure 20.2
Hero

When a single shape dominates all others, I refer to it as the hero. The hero may constitute an image of confrontation in which a one-to-one encounter takes place between viewer and image.

Figure 20.3
Container

The hero sometimes contains active smaller shapes that are read as event. When smaller shapes act inside a larger shape, I refer to the larger shape as a "container."

Figure 20.4
Congestion of Shapes

Congestion-of-Shapes marks at center, create tension, and sometimes image. Look at Philip Guston's abstract-impressionaism, or look at Francis Bacon's work. The example illustrated here might be read in several ways.

Figure 20.5
Families of Shapes in non-figurative situation.

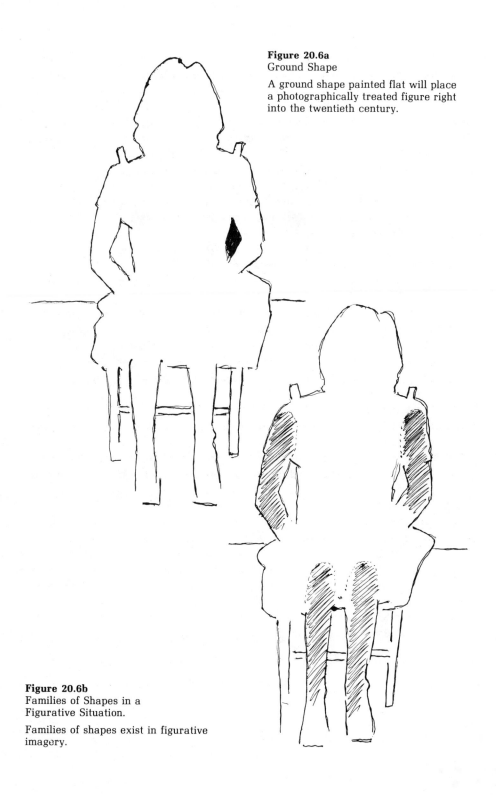

Figure 20.6a
Ground Shape

A ground shape painted flat will place a photographically treated figure right into the twentieth century.

Figure 20.6b
Families of Shapes in a Figurative Situation.

Families of shapes exist in figurative imagery.

I emphasize that to hold up, a painting must never appear flaccid of surface. A painting must be tough, all of its parts functioning in regard to one another, and economically. The painter must not relax to permit persiflage or sentiment to enter the work. It is also a matter of ethics to work toward individual solution of some aspect of the problem (idea) in each painting of a series. At point of mere repetition, the painter has lost the game.

I believe that a painting should not be decipherable in all of its parts as is a diagram. Blur, a congestion of marks, a complex of shapes, an ambiguous shape, and the behavior of form along a fracture can lend incomprehensible aspects to a painting. Vibration of color can be so dazzling that viewers cannot cope with its energy. Variety of marks can be so disparate viewers cannot complete mental mosaics, gestalts.

The chorus lines I've concocted I call "nothing paintings;" that is, there are no centers of interest, there is no emphasis on local areas. Field paintings are nothing paintings. De Kooning calls some of his work nothing paintings.

When painting organic processed imagery one must be cautious not to make marks, create impasto edges, etc., that appear self-conscious. The finished painting must appear to have grown up from the canvas surface.

By contrast, the hard-edge abstraction or super realist work must be entirely self-conscious; that is, its surface style must be consistent. The painter must not relax.

The work of mine that depends heavily on points and nondescriptive surfaces usually has islands of realism (a breast, an eye, a mouth, a nose, a belly). These I refer to as "purple patches."

I cannot emphasize enough that, while a painter requires an idea arrived at before or during the dialogue to consummate a picture, it must be borne in mind that most painting is an action controlled largely by the subconscious (the intuition, the right brain?).

Knowledge of the formal contribution of a picture's parts is primarily useful when our emotional relationship with a given work has cooled enough to allow us to be objective. It is then that we can determine whether all areas of our art function as means appropriate to our ends. While we cannot control public response to our art—it will be liked or disliked—we can assure ourselves that the painting formally is beyond reproach before it leaves our studio.

Professionalism requires this.

21.
The Big Look

Now I'd like to identify a specific quality of an achieved work of art, of an achieved painting. For lack of a better term, I call it the "big look." The look is brutal, tough. I say brutal for it represents an uncompromising functional and economical articulation of whatever happens to be concerned in the way of imagery and idea.

This look can be found in environment, both man-made and natural. The approach to Manhattan from the New Jersey Turnpike is an example of form unified. Granted that the actual distances are great; the acres and acres of reinforced concrete, of macadam and of industrial piles make for a truly overwhelming visual experience. The look is big in the aesthetic sense. So it is in painting.

I say that when creating a painting one must be responsible to work at the extremities of technique. When painting (or drawing) a "sensitive" line, it must be the most sensitive line ever made. I say that when applying a slab, it should seem to be the biggest, thickest body of paint ever applied to a surface. It is only in such clarity of technique that the big look, so implicit to the great work of art, can be attained.

This advice, of course, with the proviso that the idea embodied technically has the properties of originality and that the means agree with the ends.

22.
Material
and Method

Most times a painter must cast about to find the means to project ideas; procedure is not necessarily implicit in ideas when considering either its formal solution or appropriate material.

One has the traditional oil techniques to turn toward, the techniques of oil over tempera, of oil over oil, or direct oil. Oil paint is pigment ground while linseed oil is added. Linseed oil is chemically unstable, rots unprotected canvas, dries with aging and becomes inflexible, thereby becoming subject to crazing (cracking) because of vibration and to flaking (or peeling); it discolors and oxidizes. Acrylic paint is chemically stable, is flexible, and does not discolor. It is—probably—more permanent than oil, but it lacks the nuance of oil, although it does have great covering power.

The imagined image can help determine a painter's choice of medium. In an illusionistic image, one depicting the natural world of atmosphere, light and shadow, oil painting offers the best material. Egg tempera is an excellent medium for illusionistic imagery also.

If ours is to be an abstract painting, possibly brilliant in color, some type of paint with a polymer base is the answer. Latex will do also. Image and intention determine choice of media. A final consideration is how the painting will be processed, artists must understand the way in which they individually process to be able to choose the right medium.

Traditional gesso, a mix of powdered calcium and rabbit-skin glue, can be used as a ground on wood or fiberboard and is ideal for tempera

painting. The illusionistic painter with a desire for precisionistic painting, or pre-planned imagery, turns to this. *Tempera must not be painted onto canvas.*

For underpaintings of tempera—if formulas as in Doerner*, Mayer**, or Goldstein*** are used—acrylic or oil may be painted on prepared canvas. These materials do not attack fiber and are a barrier between subsequent oil paint and canvas fibers. Incidentally, I have used both latex and acrylic as grounds on unsized canvas.

Underpaintings, when thoroughly dry, should be isolated from subsequent oil glazes by dammar varnish. The idea is to keep the glazes from mixing with (or disturbing) the underpainting. This is quite likely to happen if one has an oil underpainting. Execution of image, then, is regulated by the nature of the glaze application. It takes a good hand and good brushing.

All kinds of individual techniques develop. Edwin Dickinson used oil paint for the most part directly from the tube. He painted a session and then, using an old jackknife, scraped down the paint, leaving a residue. Gradually the painting built up as in session after session he painted and scraped down. He, in effect, created "oil over oil" paintings.

It is mind-boggling to hear that *The Cello Player* took three hundred sessions of three hours each and that *Ruin at Daphne* took four hundred fifty sessions. Dickinson is said to have painted as many as five hundred sessions of three hours on single paintings.

If teased or worked too much, oil paint becomes lackluster or muddy.

During the 1950s, prior to the acrylics, painters turned to enamel for "long paint." Pollock used enamels and today they are crazing and flaking so badly that restorers have given up hope of saving them.

Both de Kooning and Kline used an enamel called Ripolin during the 1950s. The de Koonings, many of them on paper, seem to be holding up, even as many of the Klines have lost their "life." I don't know what caused the difference, but I suspect that it lies in the manner in which paint was applied and manipulated. De Kooning may have been more careful of drying time between applications of paint, or he may have molested the paint less. Now he employs a formula that includes mayonnaise—no enamel!

The rule is to paint wet layers over dry, or if painting wet layer over wet, to have vehicles, that is the mediums or binders, that dry at the same rate.

Enamel is not a permanent paint. Enamel constantly oxidizes. I've painted a great deal in enamel and over time surfaces begin to powder,

*Max Doerner, *The Materials of the Artist*, (New York: Harcourt, Brace and Company, 1934).
**Ralph Mayer, *The Artist's Handbook of Materials and Techniques*, (New York: The Viking Press, 1970).
***Nathan Goldstein, *Painting, Visual and Technical Fundamentals*, (Englewood Cliffs, N.J.: Prentice-Hall, Inc., 1979).

to look old and dirty. Rapid processing in abstract–expressionism simply raised hell with material. Drying times and proportions of mixes were not given consideration. Shapes were painted, wiped, changed, and repainted over and over. Some canvases began to weigh dozens of pounds. When other materials were added, such as sand, marble dust, metal chips, and wood, chunks sometimes fell off. The winner at a Pittsburgh International dirtied the floor before the show closed out!

Artists must remember that medium is a glue that holds pigment to a surface. If the glue, the binder, is not strong enough, the stuff falls off.

One of the best painters, as a direct painter, was Vincent Van Gogh. It's popular to think him crazy, but much of his work is the very model of good sensible paint craft. Vibration and pull of gravity are great enemies of painting materials. Those of you who, like myself, paint in layers or sheets (in skins of paint if you please), are arranging for eventual disaster, unlike Van Gogh. In the best crafted Van Gogh, strokes, or dots of paint, were placed side by side with intervals between. This means that the canvas has plenty of room to vibrate without affecting the paint, and the canvas may draw moisture without affecting the paint. I suspect that most Van Goghs will survive after my stuff has disintegrated.

I once underpainted a picture to send to a Pennsylvania Academy Annual. I finished my painting, trotted downtown for nails, and returned to find my masterpiece hanging like a piece of cloth from the bottom of its stretcher! Jean Dubuffet once had this sort of thing happen and bragged that this meant his work continued to have a life of its own.

In early 1957 I painted a big picture on Utrecht linen; six or seven months later, patches of paint hung from the surface, for all the world like a tree shedding bark. It became apparent that I'd applied rabbit-skin glue too thickly. I should have known better. Rabbit-skin glue is brushed on canvas to protect the weave of the canvas, to protect the fiber from oil; but I'd let the glue thicken (it should be kept thin and fluid in a double boiler) and I had, in fact, fashioned a 1/8-inch layer over the canvas. Well now, rabbit-skin glue is not made to act as a thick layer; having violated its nature, I paid the price.

Much of my career has been influenced by process painting, in particular the so-called "action painting" of de Kooning and company. I can no longer execute a pre-planned painting, even though I was trained to pre-planning. It's an emotional matter, for to achieve the sense of formal reality—integration of surface and image—conditioning since World War II meant I must process. Too bad. Too bad, for processing is detrimental to the physical survival of work when that processing insists on repeatedly changing painted areas.

I've been talking about materials of art upon which traditionalists have been dependent, when, in fact, much of contemporary art is created without recourse to traditional material whatsoever.

Some painters seldom, if ever, use a brush but instead use sponges or squeegees, dip and dye their canvasses, slosh acrylics upon their canvases, or use photographic and silkscreen techniques; who, in fact, use the most unlikely materials to make all manners of collage, combinations of media, strange conjunctions of surfaces.

We might ask, why should persons like ourselves in an age of Earth Art, and in an age of generally existential and temporary characteristics, worry about any kind of permanency in our art? I plead for the future of art. In an age that comprehends that nothing is absolute, we must act as if the art we make will last forever. I maintain that to accept impermanence and its concommitant behavior is to accept the end of art. Through our art we can act as if the future is assured.

To act as if one's art will survive is to garner credits for the future, to use good craft, even as we emblazon our despair, indicates hope; to "chuck it all" is to accept ourselves as bundles of molecules awaiting their end. Someone has said that if everything stopped moving, atoms and molecules, things would disappear, for in motion is appearance. But I contend that the human spirit is out of accord with the nature of the universe. Our art should function to assure ourselves of our permanence even as an eroding mountain seems forever.

23.

Something About Color, Medium, and Brushes

Yellows range from naple yellow, a lead color, to chrome, zinc yellow, barium, strontium, cadmium, cobalt, and hansa. Some are chromates while others are sulphides and, to be frank, I don't know the chemical differences. As an artist, I simply use them.

The impermanent lake colors—such as carmine and red lakes—are ground in mineral water. Some colors come from plants, from coal tars, and from clays. Ultramarine blue is made from Lapis Lazuli, a semi-precious stone. Other colors are composed of chemicals.

Colors for underpainting are opaque:

- Cadmium (Barium)
- Cadmium
- Cobalt Blue
- Cerulian Blue
- Mars Violet
- Mars Brown
- Venetian Red (semi-transparent)
- Indian Red
- Red
- Mars Orange

- Orange (Light, Medium, or Dark)
- Yellow
- Mars Black
- Titanium Dioxide
- Zinc White
- Cobalt Green

For overpainting use transparent colors:

- Alizarin Crimson
- Prussian Blue
- Manganese Blue
- Ultramarine
- Ivory Black
- Burnt Umber
- Burnt Sienna
- Raw Sienna
- Manganese Violet
- Cobalt Violet
- Yellow Ochre
- Indian Yellow
- Earth Green
- Viridian (Green)
- Phthalocyanine Green

The amount of medium used with oil paint determines the fluidity of application, or whether the paint is stiff or "runny." A good formula is one-third linseed oil, one-third turpentine oil, and one-third dammar varnish. Dammar resin is derived from the dammar fir of Sumatra and Batavia. Resins are derived from plant products, fossils, and living trees. Copal resins are from Mozambique, and Angola; they will not dissolve in alcohol and are known as hard resins. Mastic is a soft resin as is dammar. Mastic at its best is from the pistachia tree on the island of Chios. Mediums for oil painting may be bought pre-prepared. A late addition to oil mediums is the "gels" (G-E-L). Gels are useful in making opaque colors transparent. Painters use a variety of brushes and refer to them as follows:

- Flats are brushes with long pliant bristles;
- Brights have short square ends;
- Filberts have semi-round tufts and pointed ends;

- Stripers are long sable with flat ends;
- Writers are like stripers but are even longer;
- Dabber is made from the hair of the squirrel although called camel hair;
- Blender (or softener) is a round brush made of badger hair and mounted with wire, sometimes made of real camel hair;
- Fan, a thin flat brush of sable or bristle and sometimes horse hair, is used for stencilling. (Bristle is hog hair and sable is from the kilinsky, an Asiatic mink.)

Two useful instruments are the painting knife and palette knife. Painting knives have various sizes and are recognized by their spade-shaped blades.

24.
A Very Short History of Paint

Casein is an ancient glue known in Egypt, Greece, Rome, and China and was known to cabinet makers of the Middle Ages. It is an opaque watercolor and is derived from milk. Watercolor made opaque by adding whites is known as gouache.

Grisaille is an old method of watercolor using washes in grey, much used by British painters in the eighteenth century. Grisaille is and was often used as an underpainting with overpainting in local color. Neutral tints in red, blue, or some other hue can be used as underpainting with overpainting in local color. Sometimes the underpainting in a tint is washed down and overpainted in local color. "Wet-in-wet" means to soak the paper and paint using a generous amount of water. Interestingly, Ralph Mayer states that "the Egyptians used . . . a water-soluble binder with their colors."*

An early type of painting, tempera, used egg yolk as the medium. Sometimes distilled water and egg yolk comprised the medium. These were mixed with powdered pigment for application, usually, to a gessoed wood surface.

The Van Eyck brothers, Jan and Hubert, were the first painters in the Occident to use linseed oil. They worked during the first part of the fifteenth century. (The *Marriage of Giovanni Arnolfini and Liovanna Cenami* was painted in 1434, oil on wood, 32 1/2 " x 23 1/2 ".)

*Ralph Mayer, *The Artist's Handbook*, third edition. (New York; The Viking Press, 1970), p. 30.

In view of the fact that all artists had been trained in tempera, it followed that oil was used over tempera; thus did the tempera underpainting come into conventional use. This is an illusionistic technique. Rubens, Titian, Tintoretto, and El Greco all used some version of this technique.

Following Cezanne and the cubists, we find a demand for nonillusionistic techniques, for the picture had become an object. Eventually the acrylics—polymer (long-chain molecules)—came into use.

25.
My Work and
Other's Work

Sooner or later persistent painters discover, through trial and error, means to create their images.

Years ago I began to draw heads with graphite, ebony pencil, or charcoal, and to glue tracing paper over the features. Sometimes I drew portions of features on one or two of the overlays. I began to make chorus lines. I painted in acrylic washes and finished by painting areas such as breasts or bellies in oil. I painted large chorus lines, outlining heads and omitting legs. In time I eliminated the heads and began to cut legs out of canvas, which I nailed to hang below the stretched configuration of figures. Still later I conceived them as banners. I drew the image in graphite or charcoal, then sprayed pink or red acrylic enamel to create volume. I remembered the tracing paper and reckoned stretching red or pink chiffon over the body would increase flesh quality.

I have developed this image many times before audiences, for it makes quite a show. I've finished one that was twelve or fifteen feet wide and eight or more feet high in forty-five minutes by asking members of the audience to help squirt on the white cement, stretch the chiffon and scissor the legs. Four or five scissors cutting at the same time makes for fast cutting (Figure 25.1).

Figure 25.1
HIRAM WILLIAMS
Chorus Line Mixed media, 8′ × 12′, 1970
Collection of the artist. Photograph by Belton S Wall.

Prior to the demonstration I talk, using diagrams, about formal aspects of the image to be made: how I must think of nipples as points and of adjacent bellies as areas to create plasticity, an undulating surface across the canvas. The nipples and navels, of course, act as tensional devices because pull is created from point to point.

Figure 25.2
A Page of Chorus Lines

The idea of a crowd of figures as a single organism means that I can vary the number of breasts in size and number; the same for bellies, navels, and legs. I can play across the entire upper format by enlarging a point at either end. I can distribute the points at even intervals to create a serial effect. I can accent a breast or belly in contrast to the others. The varieties are endless. Not one of the eighty-odd I have created are alike. As an idea, coupling means to end, it is the best I have had.

Figure 25.3
HIRAM WILLIAMS
Skinned Crowd, Two Skinned Tables, Skinned Plate, Saw, and Hammer
Mixed media, 10′ × 30′, 1976. Installation view.
Collection of the artist. Photograph by Walter Rosenblum.

The chorus line led to "skins." I concluded that every object could be "skinned." I've made a number of such images, such as this one.

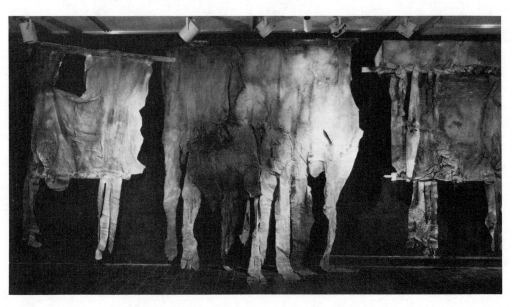

Figure 25.4
Skins (1)

Figure 25.5
Skins (2)

Figure 25.6
Skins (3)

Figure 25.7
Skins (4)

30 ft.

Figure 25.8
Nudes

I'm frank to say that had I not known of Claes Oldenburg's "soft sculpture" (every object can be soft) it's unlikely that I'd have concluded every object can be skinned. Think about and imagine the conformation I can achieve: Skinned chairs, tables, all furniture, vehicles, crowds, trees, buildings, boulders, whales, sharks, kitchen utensils, engines, plants, and on and on. I fashion these of six or seven ounce duck, chiffon, red and black acrylic spray paint; fragments or areas covered by chiffon are dipped in Rohm and Haas Rhoplex.

They are illusionistic enough to lead a New York critic to write that I was using cowhide these days!

I dream of a "clothesline" on which I'll hang skins. It could be hundreds of yards long.

I have just described a chorus line and a skinned figure or object series. I believe painters should paint in series. What can happen to the picturing of an orchard? A vista? Borders of a still life? A stretch of woodland? What can be done with a highway? (See Figures 25–4 through 25–7.) I turned my attention to the nude figure (See Figure 25–8).

26.
Uses of Art History

Robert Motherwell spoke truly when he declared that the painter confronting a canvas must know all of art history. Without a mental inventory of those forms developed over time for reference, we painters are unable to create original imagery.

Painters must cultivate an aptitude for recognizing an idea and an ability to pursue form variations incipient in the idea through a series. Let me illustrate by reviewing those contingent circumstances when I painted a group of "tablescapes."

Let us look toward Picasso. Picasso created tablescapes always influenced by the cubism he and Braque had invented. We observe he has tilted a table top so it becomes a direct reference to the primary plane. We are conscious of the devices of cubism: simultaneity, "faceting" of objects, transparency, and overlapping of planes. We experience the tablescape as a body of congenial form, each element supporting the visual relationship of the others. Looking over a tablescape by Ben Nicholson, we find that its form relationship to Picasso is marked, but the work is more open, more austere, presenting a sparse and rigid appearance. The difference between the Picasso and the Nicholson is in the geometry of Nicholson, and for this reason we enter a different world than that proposed by Picasso.

Look at a table painting by John Paul Jones. We see again a debt to Picasso and cubism, but a couple of things make a new idea. One, the faceted

objects on the table are presented in a blur of motion and, two, the facets "cluster". So we have yet another idea—"blurred cluster"—suggesting yet another world.

Morandi reveals his debt to Cézanne and cubism in the way he modulates passages across the faces of the clustered bottles so typical of his theme. But—mark you well—cluster is the idea: vessels crowded together, a gripping vision of loneliness. They are figures of endurance set against formidable aspects of environment.

We look toward a table by Dubuffet and see a roughly hewn monolith, pitted and incised, a table presented as though it were of stone, primitive and forbidding of creative comfort. It is a sign that things for man have not changed in the essential from times ancient.

We look toward a table by de Stael. We look toward a table by Wyeth, starkly puritan but magical, and for all that, the more real. I knew intimately of tablescapes by my friend Enrique Montenegro. I knew that I must be cautious not to be influenced by him.

I mulled over tables. What do they mean? As I had been painting skins, comments on man's inhumanity to man, as well as *memento mori,* it was not long before I reached a conclusion; namely, that awful purposes are served by tables. Carcasses are consumed from them. That wonderful roast we are eating was alive a few days ago, sensate and reveling in a community of its kind in, no doubt, a lovely pastoral setting. I would paint images of tables made of meat (Figure 26.1).

Figure 26.1
Meat tables

Figure 26.2
Tables (1)

Figure 26.3
Tables (2)

Figure 26.4
HIRAM WILLIAMS
Tablescape oil, 30″ × 40″, 1972
Collection of the artist. Photograph by Max Skeans.

Figure 26.5
HIRAM WILLIAMS
Big Studio Table oil, 6′ × 8′
Collection of Mr. and Mrs. Robert Mautz,
Gainesville, Fla. Photograph by L. Vance
Shrum

During the period of the skin images, I had asked myself what could I do about landscapes? Had a hunch I could utilize the materials approach that had been serving me. Indeed, I had already imagined possible images. I had both idea and method!

As always, I searched my memory for antecedents, no use bothering if some other painter or painters had accomplished this. Others had used the principle, which involved looking through the painting's surface in various areas.

Once I had seen a rectangular piece by Robert Morris made of lead. Squares had been cut into a flat leaden plane and items such as a metal hook were recessed in these openings. Jasper Johns printed a lithograph, mostly surface. Several scrambled shapes are revealed as they extrude from under that surface. I can cite other examples, but having taken stock, I thought my strategy held potential for singular work.

I stretched raw canvas duck dipped in Rhoplex. At the lower left corner, using a combination of charcoal and red spray paint, I created an organic mess (intestines, liver?) and stretched red chiffon over it. The chiffon had been dipped in Rhoplex. Another large piece of raw canvas duck was torn to establish the ragged edge of a hole through which the intestines could be viewed. The top skin had been soaked in Rhoplex. Figure 26–6 shows the result.

Figure 26.6
Hole (1). (Wounded landscape!)

Figure 26.7
Hole (2) (Emerging Figures!)

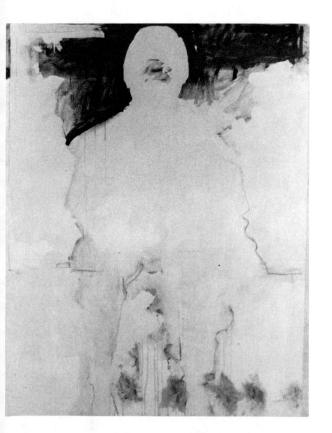

Figure 26.8
HIRAM WILLIAMS
Portrait of My Father oil, 79″ × 60″, 1976
Collection of the University Gallery, University of Florida. Photograph by Max Skeans.

27.
Verbal Approach to Creativity

Does a painting suggest its title, or did the title suggest the painting? It works both ways. Paul Klee is said to have titled his works, for the most part, after their making. He called this the baptism.

I don't know for a certainty, but de Kooning's *Ruth's Zowie* must reflect the response of someone upon encounter with the painting. On the other hand, Charles Burchfield's *Wind on a Hot September Morning* sprung from his specific intention to depict the event. The majority of Burchfield's titles describe his intention prior to painting.

Abstract paintings may go untitled, be numbered in a series, reflect the formal problem or mood, or bear a fortuitous title. Motherwell has painted dozens of Elegies, comments on the disaster of the Spanish Civil War. They have long since ceased to be comments on that debacle and now are painted as "general metaphors of the contrast between life and death. . ."*

Object, subject, and theme can be responsive to titles—the more abstract, the more arbitrary the title. Paintings often are titled tongue in cheek. One can elicit imagined images by devising a list of titles, never mind how silly. As example, I selected as an objective correlation the banana and devised titles that referred to either the states or appearance of the object:

*Board of Trustees, *A Profile*, (Washington, D.C.: National Gallery of Art, 1978), 44.

- *Drunken Banana*
- Spastic Banana
- Polka-dot Banana
- Flattened Banana
- Skinned Banana
- Blurred Banana
- *Clowning Banana*
- *Striped Banana*
- Dizzy Banana
- Laughing Banana
- Crazy Banana
- Split Banana
- Alphabet Bananas
- Bread-like Bananas
- Crawling Banana
- *Silver Banana*
- Gold Banana
- Rainbow Banana
- Banana under Cloud
- Rained-on Banana
- Stepped-on Banana

Figure 27.1
Bananas

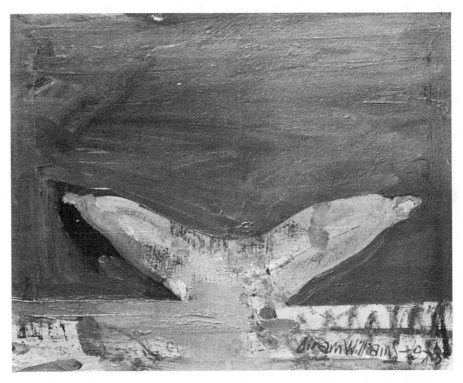

Figure 27.2
HIRAM WILLIAMS
Yellow Banana oil, 20″ × 24″, 1977
Collection of the artist. Photograph by Max Skeans.

Substitute "table" for "banana," and we have Drunken Table, Spastic Table, Striped Table, Dizzy Table, and so on. Substitute "chair," "clothes," "trousers," or "machinery." If you have a propensity for abstraction, substitute either organic or geometric shapes.

To stimulate ideas in students, I have had some success by cribbing titles from Miro, but I do not show them either slides or reproductions of his work. As a matter of fact, I do not give them the source of these titles until they have finished their projects. They have obtained some happy results:

- *Birth of the World*
- *Hand Catching a Bird*
- *Snail, Woman, Flower, Star*
- *Ladder of Escape*
- *Dog Barking at the Moon*
- *Red Disc in Pursuit of a Lark*

Surrealism is considered by some to be the greatest of modern art movements. Language played its role, led the way. I've used this approach to learning by using Dubuffet's titles:

- *Radiant Landscape*
- *Grotesque Landscape*
- *Texturologies*
- *Messages*
- *Soils and Grounds*
- *Geologies*
- *Metaphysical Land*

For the same purpose I've used titles from Claes Oldenburg (documents from *The Store*, 1961, and *Ray Gun Theatre*, 1962). I quote only a few of the many titles to be found in *Store Days*, published in 1967 by the Something Else Press.

- *Sewing Machine*
- *Cigarettes and Smoke*
- *Bacon and Egg*
- *Red Pie*
- *Small Yellow Pie*
- *Four Flat Pies in a Row*
- *Fur Jacket and White Gloves*
- *Big Necklace*
- *Ice Cream Bar*
- *Red Sausage*
- *Pile of Toast*

I have used lists from others such as Burchfield and Edwin Dickinson, and I have made lists of my own about landscape:

- Metal Landscape
- Shuddering Landscape
- Sand Landscape
- Meat Landscape
- Drunken Landscape
- Landscape of Mugwumps
- Polka-dot Landscape
- Rainbow Landscape

- Macadam Landscape
- *Shore Birds*
- Stepped-on Landscape
- Joyous Tree (or Garden)
- Happy Forest (or Garden)
- Landscape of Cucumbers
- Landscape of Watermelons
- Skinned Landscape
- Wounded Landscape
- Landscape of Exploding Meat

Figure 27.3
HIRAM WILLIAMS
Shore Birds oil, 6′ × 8′, 1979
Collection of William and Eloise Chandler.
Photograph by L. Vance Shrum.

I made a list under "Piles" as heading:

- Cloth
- Garbage
- Boxes
- Rocks
- Sand
- Jewelry
- Cutlery
- Hats

Another list under heading of "Marching:"

- Chicken Drumsticks
- Shirts
- Hose and Socks
- Trousers
- Bacteria (other creatures)

Figure 27.4
HIRAM WILLIAMS
Man Confronting Himself oil, 8′6″ × 5′, 1977
Collection of the Museum of Art, Fort Lauderdale, Fla.
Photograph by Roy Craven.

I've done earth forms:

- Caves
- Crevasses
- Holes in the Ground

I've done rocks as cairns, walls; I've done mountains, victims and heads (Figures 27.4 through 27.12).

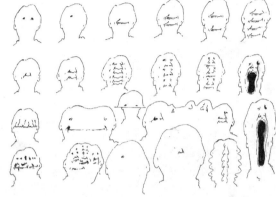

Figure 27.5
Heads (1)

Figure 27.6
HIRAM WILLIAMS
Heads oil and latex, 72″ × 96″, 1961
Photograph by Oliver Baker.

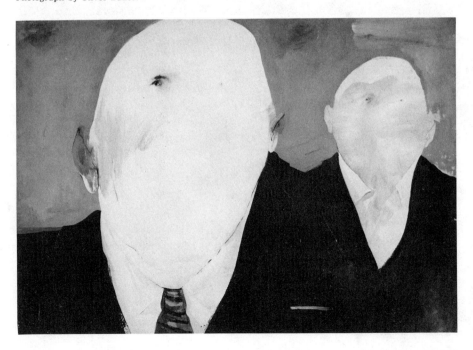

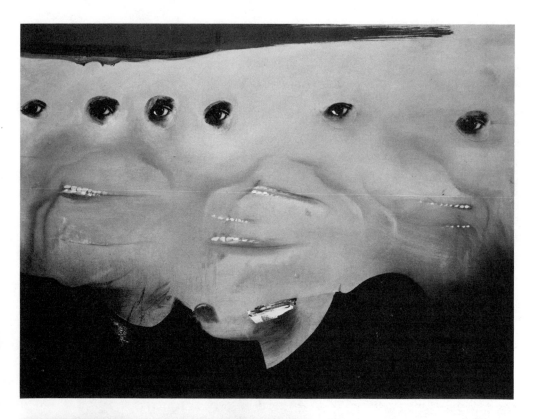

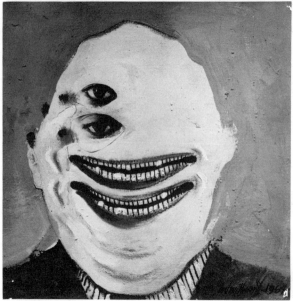

Figure 27.7
HIRAM WILLIAMS
Crowd of Gazers oil, 36″ × 48″, 1965
Collection of the artist.
Photograph by Harry Bennett.

Figure 27.8
HIRAM WILLIAMS
Laughing Rotarian 18″ × 20″, 1964
Collection of Dr. Sol Kramer Estate.
Photograph by Harry Bennett.

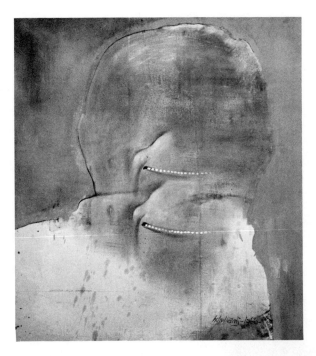

Figure 27.9
HIRAM WILLIAMS
Spectator at a Crucifixion acrylic,
68′ × 60′, 1966
Photograph by Geoffrey Clements.

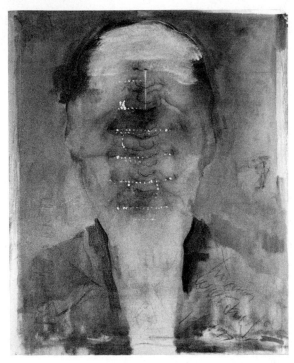

Figure 27.10
HIRAM WILLIAMS
Smiling Man oil, 36½″ × 30½″, 1977
Collection of the University Gallery, University of Florida.
Photograph by Roy Craven.

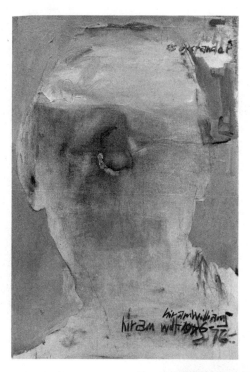

Figure 27.11
HIRAM WILLIAMS
Bystander oil, 30″ × 24″, 1976
Collection of Curtis Williams.
Photograph by Roy Craven.

Figure 27.12
HIRAM WILLIAMS
Turning Gazer collage of oil and paper,
80″ × 68″, 1965
Collection of Whitney Museum of American
Art, New York.
Photograph by Geoffrey Clements.

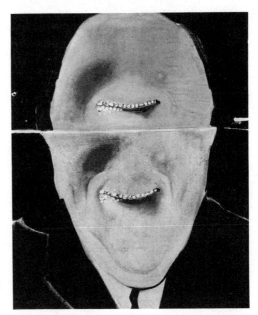

Figure 27.13
HIRAM WILLIAMS
Head as a Filmstrip oil, 4′ × 3′, 1965
Collection of Curtis Williams.
Photograph by Geoffrey Clements.

Figure 27.14
Punchbowls.

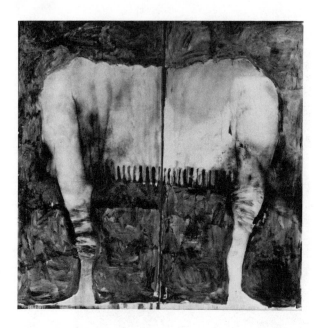

Figure 27.15
HIRAM WILLIAMS
Stretched Man oil 104″ × 103″, 1979
Collection of Weatherspoon Art Gallery,
University of North Carolina.
Photograph by L. Vance Shrum

The male figures I have painted are all
multiple views of the single figure.

Figure 27.16
HIRAM WILLIAMS
Speeding Searcher oil and enamel,
96″ × 72″, 1959
Iconography Collection.
University of Texas at Austin.
Photograph by Oliver Baker.

The idea of "stroboscopic men" was con-
ceived to depict the movement of one
figure through space. (See also Figures
27.17 and 27.19)

Figure 27.17
HIRAM WILLIAMS
Blind Searcher oil and enamel,
96″ × 27″, 1959
Iconography Collection, University of Texas at
Austin.
Photograph by Oliver Baker

Figure 27.18
HIRAM WILLIAMS
Man with Bowler Hat oil, 72″ × 48″,
circa 1975
Collection of William and Jeanine Stephens.
Photograph by William Stephens.

Figure 27.19
HIRAM WILLIAMS
Running Man oil, 8′ × 6′, 1980–81
Collection of Curtis Williams. Photograph by Roy Craven.

"Running Men," a series of four paintings, was conceived by imagining a person running directly at me.

Figure 27.20
HIRAM WILLIAMS
Challenging Man oil, 8′ × 6′, 1958
Collection of the Museum of Modern Art, New York. Fund from the Sumner Foundation for the Arts.
Photograph by Roy Craven.

Challenging Man was one of several paintings done in 1958 and early 1959, the last in a series entitled "Guilty Men."

Figure 27.21
HIRAM WILLIAMS
Incubus oil, 6′ × 8′, 1961
Collection of the National Museum of American Art, The Smithsonian Institution, Washington D.C. Gift of S.C. Johnson & Son, Inc.
Photograph by Vance Shrum

Incubus was painted when I attempted to combine the front and back of a figure in one configuration. I called this series "Overhead Men" (Figures 27.20 and 27.21). I have also done "seated figures" (Figures 27.23 and 27.24).

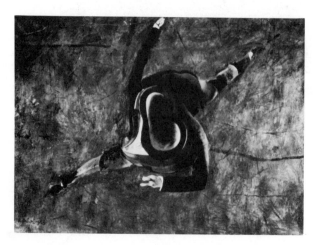

Figure 27.22
HIRAM WILLIAMS
Scurrying Man oil, 6′ × 8′, 1959
Collection of Kim Williams Boyd.
Photograph by Roy Craven.

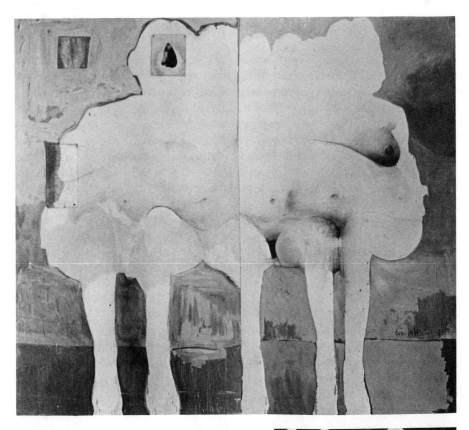

Figure 27.23
HIRAM WILLIAMS
Audience (Panels No. 1 and No. 10.) oil,
102″ × 102″, 1968
Collection of St. Mary's College of Maryland.
Photograph by Kathran Segal.

Figure 27.24
HIRAM WILLIAMS
Audience (Panel No. 3) oil, 102″ × 60″, 1968
Collection of St. Mary's College of Maryland.
Photograph by Kathran Segal.

Purest form seems to me is that which comes directly from the action of materials (Pollock's drip painting). Next best is a breeder idea such as Oldenburg's "softness:" soft typewriter, soft bathtub, soft light switch, and so on. Oldenburg's gigantism has yielded startling imagery.

The idea of blowing up common objects to gigantic size is fascinating, but most of us must make do with lesser ideas.

We develop vocabularies, ways of using shape and material. In 1917, Charles Burchfield invented signs for imbecility, brooding, evil, morbidity, which he incorporated into his landscapes, thereby making metaphors of them. Burchfield painted entire vistas without depicting natural shapes and surfaces. He substituted invented tree trunks, foliage, and branches. He devised his own scale relationships. He learned to paint trees in elevation that seem to tower high by painting the base of the trunks wide and then rapidly narrowing the trunks, stepping back the trunks at intervals, which is to say he devised his own perspective, his personalized foreshortening.

As I've followed the career of Jim Dine, I've come to admire him. Dine has taken as his theme the things in his immediate neighborhood: tools, clothing, bottles, all of which have established the *World of Jim Dine.*

I look toward the Englishman, Stanley Spencer, to find that he created a visual saga of life and appearance in his native village of Cookham. I look toward David Hockney to see his world abuilding, an artist of perception, of honed sensibility.

Good artists in the past have created their metaphorical worlds, are doing so today—right now—and so can you and I.

28.
To Persuade

The authority of a painting, its power of persuasion, is established through technique in support of some form of unity. Means are seen to be appropriate to the ends. An air of authority is also conveyed as the interest of the artist is demonstrated, as our concern for what we do is made visible by our "follow-through," that is, our expressive emphasis, a kind of conviction that has been made visible, belief made evident.

Lack of concern is readily apparent in a piece not motivated and processed out of need. It is simply asking too much of the viewer to accept as believable something the painter cannot believe in. I am suggesting, then, that the believability of a work is, in part, a reflection of the artist's own belief in it.

The artists' own beliefs are emotionally seated. They feel an idea to be expressive enough to obtain as art. Implicit in the idea may be an expression of banality, of violence, of force, of ambiguities, layers of meaning. The painters' task may be to present a square, to realize a tensional play between two areas of color. A desire to present colored planes, it must be said, can be as deep, as urgent an expressive need as the urge to express the reality of a nose. Nor do I mean to indicate here that the artist must wait for a moment of belief (inspiration?). I am of the conviction that the good artist's work becomes convincing during engagement with an artistic problem, while processing his or her work. For it happens that as the work becomes crystallized, so does our belief as the propitious instant is

offered to us to cast out secondary influences and concentrate upon a primary expression of feeling.

The search is always for the real, the lie of art that becomes the truth of experience. As Andrew Wyeth painted the bridge of the nose in his portrait, *Karl,* he identified with the slope of flesh as it moved into the hollow that held Karl's eye. How tenderly Mark Rothko brushed the plane to attain just the right glow of color!

All desire to push an idea to its limits (a most proper desire!) must be governed by the rational mind else the painting becomes overdone or becomes clogged, the idea immersed in an overload of extraneous matter obscuring the sensation of an impulse that sought to embody the idea. Over-painting is the curse of the painter. Listen to us talk. How often we tell others that an hour back our painting was a fine, splendid thing, admitting that at a point we had arrived at an expressive unity and now have irrevocably lost it.

The painter puzzles about "finish." We feel something real should appear with our work. How excitedly we react to the possibilities of our half-completed canvas, for in its unfinished state are possibilities for a wondrous realization. The rawness of the unformed elements embodies potential for an ordering of an elemental and viable reality. How then to have both! The barbarous skeleton and flesh of the work in process plus the satin skin of an achieved canvas, the expressively essential polish of professionalism.

The above generalities apply to all painters' searches after the real and to all processes. Yet hard-edge abstraction is not figure painting. The problems are different, each to each. The final look is different. What they have in common is an economy of means suitable for their various ends. What they have in common is an artist, driven by a need, who has found a problem peculiar to an area in painting and who has found technical means to present an apparition evocative of a reality—to arouse emotion through the eye of the viewer. In the painters' steadfast belief is our power to cause belief in the mind of the viewer.

29.
Random Jottings

Over many years I have formulated a number of axioms. As I examine these I recognize a certain archness, a shrillness perhaps, even a disagreeable pugnacity permeating them. Yet I feel them to be stimulating enough to arouse thought and therefore worthy of your consideration. In general, my students have reacted well as I have used them in lectures and discussion. I hope you react as well.

- Who is the painter? The painter is a subjective person giving form to feelings about objective evidence saying THIS IS ME, HERE I AM, SEE!

- Art acts as a mirror. Its reflections of the world constitute lies that appear as truth. Van Gogh and Picasso knew this. Da Vinci knew this.

- The truth of a given work of art is incurred by reason of its internal behavior. For each work of art is a world of form that has its own laws. If the laws peculiar to a given work of art are violated, the work fails to convince. Its function as a mirror to our emotional life is cancelled.

- The artist must be apprehensive that his talent, skill, and knowledge are so demonstrated that his work of art acquires an air of authority; an air that requires that the make-believe, exaggerated, and literally untrue statement embodied in his art piece be accepted as truer than life.

• It is my opinion that a given painting can be talked about in terms of the paint's visual function and in terms of the associational field of reference formed by the image; the first is a matter of mechanics, and the second is literature. Everything else in a painting is of a nonverbal order and should be accepted as such. It is the nonverbal overlay that makes a painting a painting.

• Great figurative painting of the past challenges us to match its greatness. Our emotion for the figure (as ourselves) invites us to image it anew.

• Some painters hesitate to acknowledge influences that have proven beneficial to the formulation of their "styles." They prefer to infer that they are without debt. This is shameful, because such debts are necessary contractions; painting could not exist without them.

• It is easy to conclude that the majority of debts are to well-known painters, painters who are much publicized, and it is true, the publicized painters are likely to be the best painters. These painters must assume responsibility for the future of art.

• Strangely enough, although it is the painter's business to be original (that is, creative) most are so tangled within influences or so joined in a "movement" that it is impossible for them to attain that singularity of image that constitutes fresh vision. Painters, too, are trapped by conceptual modes, and it is as hard for the painter to escape stereotyped conditions of thought as it is for the layman.

• Another failure in art is the "joiner." Just as some people are moved compulsively to become members of the Kiwanis, Rotary, Elks, and Moose, so there are painters compelled to belong to movements, schools, cliques, or whatever one chooses to call a cluster of painters who assemble together under a common aesthetic banner.

• Original painters have clarified their purposes. This gives their work a look, and it is the look that influences the weaker painter. Even strong painters may find their work pervaded by influence. Such painters recognize this and take steps to rid their panels of the intruding appearances or to assimilate the intruding appearances.

• Man comprehends the universe as an organization striated between microscopic and astronomic reaches. All reaches but the physical are outside human scale and man's direct comprehension. The artist draws motifs out of the physical strata, that realm of experience where actual confrontation takes place. It was Marc Chagall who said that the real miracle in

the universe is the presence of the material, the visible world. It is herein and as image related to the visible world that art exists.

- It is axiomatic that none of us escapes our times. We look at early art and find Paleolithic man believed in magic. Apparently magic permeated every aspect of his life. Art was handmaiden to magic, even magic itself. There is an aura about the work of art not explained by the material or by the activity that created the art. Therefore, though art is of the physical, visible world, the effect of the fine work of art lies in its transcendence above mundane life.

- We look toward the Renaissance and the image of man projected as though he were a God. When else could perspective, a system placing man at the center of things, have been invented? And what of our time? We paint images that assault us as the magnitude of the universe assaults us.

- Perspective does not accurately describe the size relationships in the natural world; rather, it describes how our eyes interpret light. None of us sees things as they really are.

- Diogenes besought Alexander the Great to stand aside from obstructing the sunlight. Diogenes went about with a candle that he might locate truth in some dark corner. Diogenes explains the role of the artist, a searcher after truth despite public obstruction.
 Society has always had mixed feelings about the artist. On the one hand we are felt to be malevolent and obstructive creatures; by others, we are held in awe as magicians. Plato would have had us thrown over a cliff. Alexander the Great would, if he could, have traded places with us.

- A painting is not the measure of the painter. The painting measures something else.

- Disturbing pressures of the Reformation led to the assertive arabesques of the Baroque, to El Greco and Rubens. In the eighteenth century horses were painted sniffing and enjoying the scent of flowers. By this sign alone might not we suspect that the science of botany had come into being? Art reveals the times.

- As a young painter, Charles Burchfield designed wall paper. His firm gave him one hour and a half for lunch. He ate his meal in fifteen minutes so that he might spend the next forty-five drawing. He gathered materials for pictures as he observed on the trip to and from the plant. He painted during evenings, often splashing cold water over his face to stay awake.

• Design courses teach all manner of color theory, largely reductions to systems. The fact is that color preference as far as "chroma" is concerned is largely subjective. Painters color their worlds of form in their own way.

• An individual color is affected by environmental colors so that we can say a color is being used properly only if we know its context and expressive purpose. Overlap does more to place shapes in depth than relationships of "hot" and "cold" color.

• How wonderful! Don't you see that no two-dimensional visual art could exist were it impossible to make a line.

• Painters attuned to what has happened in recent art history process their paintings until "subject becomes object," until the picture takes on an image and patina that makes of it a "thing." Francis Bacon speaks of event. He means by this a painting does not so much describe experience as be experience, the experience of a painting.

• The figurative idea I have been exploiting these past several years has time and again seemed to terminate, but I find, usually when I despair most deeply about its future, that another possibility for an extension of it is vouchsafed me. The logic in the unfolding of a breeder, of a germinal idea, is readily visible after the fact but is obscure as to the pattern of its unfolding. It would be comfortable to sit back knowing one could merely demonstrate a bit of technique and call oneself a painter; it would be comforting to know one were in command, but it does not work that way. Rather we are at the beck and call of a dimly perceived idea that seduces us, beckoning us across swamps and pits and tangled briers, always fleeing ahead. And then we catch up to find it has been by our side all of the time. We pause to catch our breath, and it is gone.

• I paint subjects that are known to all and hope to reveal this familiar imagery as new discovery. The human image is nearest to our viscera as a meaningful symbolism, but other shapes—rocks piled as cairns, as barricades, as walls, as ruins—have their symbolic value. And, of course, it is in the symbol that we find our various realities. Therefore, the good painter would paint the image of a coffeepot so that as a sign it becomes the quintessential pot. The painter who does this will transform our entire experience of coffee pots and of art. I value the associative possibilities of images I create, and in these times, when we find the human situation a desperate one, it follows that I would use the human figure to underline man's plight. Exploration of material and shape for plastic purposes no longer holds fascination for me, although I try not to forget that a painting

and a picture are not the same thing. The picture becomes a painting as we exploit it plastic potentials, and despite the advocates of nonrepresentative images, I'm satisfied representation can be as plastic as the nonrepresentative. In art we can have our cake and eat it, too.

• No artists know until they are in the painting what is to be the painting's outcome.

• I do not teach creativity. I teach the nature of painting, and it is the students' business to be creative. They use tools I have given them.

• Lay persons ask painters why Norman Rockwell is not considered by artists to be a painter. I would like to show you why. Do you recall Rockwell's Saturday Evening Post cover of November 24, 1951, titled *Saying Grace*? This picture depicts an elderly woman seated with a youngster in a restaurant with heads bowed and hands clasped in prayer. Railroad yard workers are present, touched by their reverence. It is apparent that the woman and child had become lost in the city and have entered to eat in a strange restaurant located in a tough neighborhood. They will eat and leave to find their way home. The men will leave better men for having witnessed the scene, for they have been brought to remember home, mother, and Sunday School.

Now that's story telling. My point is that the position of the personae could be changed in any number of ways, but this would not affect the picture at all, for it is without formality. It is not art.

Recall Whistler's *An Arrangement in Grey and Black* (Whistler's Mother): not a great picture it seems to me, but a painting. Whistler's mother sits in profile, behind her hangs a curtain and two framed reproductions. Now were we to move any element in the painting we would have a different painting, for to disturb a formally unified work in any part requires compensatory changes to obtain another unity. The formality makes it art.

• During processing a painting moves from unity to unity. Painters sense when they have happened upon an arrangement of form that can be called a final unity.

• Important matters should concern us first and integrity is a first concern. A painter's expression of experience is formulated through both the conscious and the intuitive seeking out of form. And it is in the act of formulation that a painter encounters the nature of integrity.

We use the word *integrity* advisedly, for when painters paint, they are involved in a matter of ethics. We must understand that painters' art is always in crisis; they are committed to the proposition that the work must be individual, that is original, and they seek to arrive at a formulation free

from copied elements. And while influences force themselves willy-nilly into a painter's consciousness, it is in the creative painter's struggle to fend off influences that the strength of the will to achieve integrity is revealed.

If the above statement is true, it is strange that painters must be schooled by imitation to an understanding of other painted worlds—visual metaphors painted by other people—before they can possibly propose their own, and yet this is so. It is as though they must act the plagiarist initially so that they may become ethically self-sufficient later.

In fact, a painting is founded upon the illusion that a painted surface can appear to have depth and movement—a kind of deception. Therefore, a painter's talk of "honesty" would seem to be imbecile unless we understand that it is in the *manner* of artists' commitment to this deception that the nature of their integrity—its strength or weakness—is disclosed. When painters have had the strength to rely upon their own ideas and technique, the painting—a relic of ethical adventures—announces its verdict: "Here is an honest painter."

Other concerns influence painters' honesty. Good painters require of their materials, technique, and gesture an economy of function sufficient to the realization of their intention. They abhor means superfluous to, or short of, their ends. They insist that the picture be "painted through." We are using "painted through" to mean a complete unity of surface and image, of plane and idea. The well-known axiom that "the means must be suitable to the ends" describes what must lie at the core of all good works of art.

Painters are surrounded by other challenges to their integrity. Career painters will sooner or later encounter the commercial world, the time when their art becomes a commodity. How tempting it is to follow up the sale of a picture by painting another similar painting in the hope that it too will sell. There is no wrong in the fact that a painting sells, but there is wrong in painting a picture *for* sales, because it is at this point that the painter gives up the creative quest, with its inherent chances for failure.

Painters' integrity is challenged when they continue to use a style they have created to reduce the possibility of failure. In no time they become their own mannerists, kind of mimics of their former selves and stopped growing as artists.

Painters' integrity is challenged when they commence to paint to be seen, when their works become no more than manifestations of their egos. They commence to play a charade wherein they are "painters" but mock ones. They have no rapport with output, and their expression is fallow.

What matters is your expression. What matters is that you must paint, for you have something to say through painting. What matters is that you are your talented self and any violation you perform against that self lessens that talent. In the area of art each of us is our own policeman, but each of us holds the potential of becoming our own thief.

- "The life so short, the craft so long to learn, . . . " - Geoffrey Chaucer.

- Old Hokusai died in 1849 and lamented on his deathbed that had he been given five or ten more years he could have become a great painter.

- Show me a painter who consciously creates texture and I will show you a decorator. In my view, texture should be the result of processing or of descriptive need.

- A painting should not be "composed." The composition of a picture is imagery resulting from processing.

- A single described feature within the contour of head or body requires the viewer to imaginatively supply missing features.

- Someone has said that the creative person is a person who can be comfortable with the unfamiliar, one who can be at ease with the strange. This makes sense, for when a new something is brought into the world, it is as new and as unfamiliar to its creator as to anyone else. The creator then, is a person who allows the strange its being; one who does not kill off the newborn though it be bizarre, even a monster.

- It saddens me to confess that I have known a brace of academic painters who have given up painting and have become brilliant classroom roll callers.

- Theme, idea, and intention do not explain a painting nor do they define a painting. These are but governors for processing the image. At some point during the creative act, the format assumes the properties of a painting. This, as I say, cannot be defined or even explained. The best we can do, as someone has said, is to recognize that here is a painting. We know one when we see one.

- The painter trying to pin down the idea uses materials, and out of the struggle with and through these materials the picture comes to be finally resolved. The struggle is intense and at times extremely painful.

- You are in competition with the best creative talents from the Renaissance to the present. Art is concerned only with ideas of the order of genius. Art is aristocratic; and in the long run, time and criticism do not play at democracy.

- Artists are forever issuing manifestoes and declarations of intent, pri-

marily to convince themselves that their purposes are valid. Artists carry about the annoying hunch that they are on the wrong side of the fence and that the hay may be on the other side. Some painters attempt to paint in all fields at once lest they miss the harvest. I hasten to assure you I speak of well-intentioned painters who happen to be compelled by inner necessity to feel certain that they are right, and the only evident assurance is to paint in a current and critically popular vein.

• Some artists are sensitive about comparisons of their work with that of others. I don't think that they have anything to worry about if their indebtedness is not so great that their vision and personality are submerged. In my experience those painters who have come by and used influences properly are perfectly ready to recite influences that have been and are forming their vision. When we are considering influences, we must do more than mention the influence of one individual upon another. We must bow in the direction of other sources of influence. Clive Bell speaks of "period vision"—the prevailing style of the day. At some time after a period of art has drawn to a close, we can see the affinity of behavior. There will appear a general linkage in similarity of form and comment. And although we are still in such a period, a period stemming from the cubist discoveries, it seems to me it is already easy to see how the pattern has been shaped. The time lapse in our generation has not been as necessary for our understanding as in the past. Our communication informs us day by day of change in the art world, and we have masses of information immediately available so that, if our eyes are open, we should have some idea as to the stylistic nature of the period. But this immediate knowledge of where we are stylistically can be disconcerting and even detrimental, for this very knowledge prevents our having open eyes toward the future. During the geometrical, nonobjective movement that was in the air a few years back, I found myself joining the throng. There seemed to be nowhere else to be. Many fine talents must have been swallowed up in this fashion over the past number of years, talent unable to assert itself in the backwash of a movement. It is our problem as painters to hold ourselves sufficiently aloof from art movements that we may better determine our own identity.

• Biographical reading of the lives and thoughts of artists in the past and reading of philosophies and creative novels are indispensable to growth; wherever creativeness can be found in the arts, leaven for the creative painter is to be found.

Dr. Donald L. Weismann has completed a series of video-taped programs that were produced by *Radio Television*, the University of Texas, with financial assistance from The National Educational Television and Radio Center. These tapes are being shown upon campuses about the country and are intended to be shown to classes year after year. Dr. Weismann has

called this series, "Mirror of Western Art." The units have the titles "The World of Objects," "The World of Light," "The World of Atmosphere," "The World Beyond," "The World as Cosmos." These titles indicate the breadth and depth of the art that past and recent masters have bequeathed to us.

Think of their names: Giotto, Rembrandt, Rubens, Van Eyck, Masaccio, Caravaggio, Renoir, Turner, Monet, Pissarro, Hopper, Hals, Brueghel, Watteau, Vermeer, Harnet, Courbet, Goya, El Greco, Boucher, Grünewald, Tiepolo, Cézanne, Picasso. The program's brochure set me thinking: Just what is my indebtedness to these artists? At first all I realized was that my obligation was enormous. So I tried to pin down, with whatever precision I could muster, my debts to them—to each one of them.

Chardin and Vermeer gave me a feeling for the value to be found in modesty, that small worlds descriptive of the commonest objects to be found in one's immediate environment are capable of assuming symbolic value of great spiritual dimension. These painters also speak of home, of intimacy, and of the regard people can have for material possessions (and how their pictures transcend the ages with their statements of ever enduring concerns). Bonnard, too, continued this tradition. Harnet in ways is related, but to me he is colder, mechanical. However, Harnet offers his lesson also—don't be seduced by objects, objects for themselves.

Not so much Franz Hals, but certain of his later followers teach the dangers of bravura, of the glib, facile brush—of the shallowness of excess, of immodesty.

Giotto, Masaccio, and Rembrandt teach solidity, permanence. They are anti-facile. Their imagery is monolithic, everlasting.

Must I say it? Rembrandt is the greatest of all. As a painter, I am sometimes woeful, depressed in spirit. On these occasions I go to Rembrandt and my faith in painting is restored at once. He is the lodestone. How many painters, I wonder, have turned to Rembrandt in their hours of travial? Of my contemporaries, it is to the late Edward Hopper I turn. Hopper helps almost as much as Rembrandt. Cézanne helps, too. Cézanne grows upon one with the passing of years.

Cézanne's works have a solid substance arrived at through means of a plodding, searching application of the brush. Cézanne teaches that goals can be found. He has taught twentieth-century painters almost all they now know of plastique.

Picasso teaches us the nature of risk and of the hazards of daring. It seems to me that Picasso's body of paintings, winnowed by time and criticism, will fare badly. Many, if not most of them, it seems to me, will finally be assessed as trash. Through carelessness (or impetuosity, perhaps) he fails with regularity. Also, I think Picasso is often guilty of camouflage. Frequently Picasso makes a little bite look like a big chew. Nevertheless, he teaches the truth of that wellknown adage: "Nothing ventured, nothing

gained." When his ventures have been successful, it also seems to me, Picasso scales forbidden heights. Picasso underlines a fact of art: That it is too much to expect a masterpiece each time one paints. A masterpiece of art appears irregularly in the work of even our best painters.

I am reminded of a visit to a showing of Rembrandt's etchings. I walked by these prints, and, as I encountered them one by one, I was shaken to realize that I was finding them to be rather common. It seemed to me I'd seen better shows by Lasansky's Iowa students. Even though these students had had the advantages of advanced techniques, still, I thought, this is the *great* Rembrandt! Then I came upon the *Hundred Guilder Print.* Enough said.

Boucher and Watteau teach the dangers of commerce. Is that it? Or is it simply the dangers of conforming to an era? And if there is danger in conforming to an era, what can be done about it by the painter? I am afraid that the artist caught in such a trap is helpless.

Pissarro teaches us about the painter sold to the dictation of an artistic revolution. Monet teaches us of the painter transcending such a revolution, while Renoir teaches us how to anticipate a revolution.

But Turner was unique, as was El Greco, Grünewald, Brueghel, Caravaggio, Van Eyck. Tiepolo was good but came close to being lost in a style, in mannerism.

Courbet. Painters will think of him from time to time in the future. Courbet's sense for plastique was far from impeccable. On occasions Courbet was almost cute. But at his best Courbet becomes the painter's painter. He used paint! Velasquez, too. Velasquez teaches facility completely controlled.

I save Goya for last. Goya teaches us power of expression, of paint at the service of a statement. Our list could be expanded. We could examine Van Gogh's final paintings to learn how a powerful expression can sink to become a manner.

And there are lessons unlimited to be gleaned from close perusal of pictures by less-known painters. Artists who tried to scale heights but were unable to climb. Personalities lost in the wake of stronger personalities. Painters who lost because they were simply unintelligent. Talented painters who failed in the long haul because they lacked vitality. Painters who destroyed their potential through indifference or through dissipation.

• Certain painters have been chosen to form the avant-garde and are presumed to be responding creatively to the artistic issues of our times. Art magazines published in New York or London, the two primary art scenes, are full of articles espousing the work of those they have chosen out of the horde of aspirants for primacy in the visual arts.

Most modern-day college-trained painters accept the situation and spend their careers mightily trying to achieve recognition; to them no situation is viable other than the New York/London art scene.

But there are other art scenes. In the southwest there are the "Bluebonnet Painters," practioners of the painterly arts who paint descriptive images of fields of spring flowers. Some of them are good at what they do and, furthermore, are serious about what they do.

In Delaware, that great seafood-ridden state, I once encountered a group of impressionists just as serious about what they do even though the movement expired around the turn of the century. For them the New York/London activities are nonexistent.

Scattered over the West like grains of corn are illustrators of cowboys and horses, even though the Wild West vanished in 1870. Their pictures give no clue of this, and since their pictures sometimes sell for $30,000 each, though small, they can afford to be serious.

Primitive or näive painters abound in the land along with amateurs excitedly "expressing themselves."

Here and there are people who illustrate wildlife. There are painters who specialize in seascapes and/or boating, "maritime painters." There are painters who specialize in cityscapes or cloudscapes or science fiction. There are slews of bird painters. There are slews of portrait painters. There are slews of flower painters.

They are all most serious, and many have developed enviable skills. In New York and London there are schisms among the avant-garde. Some practice abstract art. Some are figurative. Some are concept artists. They are inclined not to speak to one another. All of them agree, however, that it is impossible to paint respectable imagery any place else other than in the two big cities. It's hard to believe that they are serious about this, but they are.

I'd like to suggest that each of these enclaves of artists give reason to be respected and point out that within their terms each style produces outstanding practitioners.

Such a one was the illustrator of African wildlife whom I saw on television recently. Now I know that there are elements in the formal make-up of modern painting about which he is ignorant, but clearly he does not need this information to do what he is doing. Recognition of his ignorance does give me an opportunity to feel superior. This makes me happy. I am very serious about this.

• It occurs to me that painting may attain some of its interest in that a picture is constructed so privately and stems in part from private sources in the painter. We all get satisfaction of sorts in watching our neighbors bare their hearts. For paintings do reveal the painter. The revelation will include a description of the painters: They are inventive, disciplined, well-trained, or they are not; understand the visual mode of the day, or they do not; they see the world freshly or without insight. For a painting is a judgment upon the painter. A painting confronts a public and tells it in depth

numerous things about its creator, while at the same time it gives the public a vantage from which to grasp one person's experience of art and nature.

And there is value to us in that painters' work is marked with their handwriting—that hand-crafted look that gives a painting its air of being a single, precious, personal offering. As long as people value another person's efforts, an audience will single out whatever is singularly stimulating to its emotions. I suggest that the marks of people upon surfaces are not the least valued elements in works lining the corridors of art history.

30.
Why Some
Give Up Painting

Creative people may be haunted by fear that their powers may one day disappear or have already disappeared. Young people choosing art as a career do so largely because they are confident that they possess unique resources for creativity. They need little concrete evidence of this, for they feel it at gut level.

Yet I have long watched aspirants for distinguished positions as artists falter and then count themselves out of the race. Gut level confidence in their talent has become lost. Occasionally they have concluded that the price to be paid is not worth the effort. They sometimes feel disillusioned about art itself, while disillusionment in their capacity as a competitor discourages some. It is commonplace to meet older painters—painters in their late fifties or sixties—who have been unable to find a personal direction, to find a vision singular enough to be their own.

This problem was endemic to those painters who were trained or who reached maturity during the era of regional painting in the late 1930s. Prepared as they were in the descriptive disciplines, painters found it insuperably difficult to grasp the meaning of contemporary formalities. This meant that they grafted cubist innovations to representative imagery, doing, thereby, great harm to their art. Numbers of older university faculty painters are, to this present day, "hung up" in this situation.

A sense of underachievement leads to doubts. Failure to make "the scene," other than a local or regional one, breeds frustration and a conse-

quent falling off of output. In instances, painters are awakened to the fact that they have invaded a field for which they were never suited; and this after years of effort.

It is safe to say that our efforts must be supported in some way. After all, Van Gogh did have the interest of his brother Theo. We may rest assured that the inheritance from his father contributed immeasurably to the success of Cézanne. His time and energy were not sapped while grubbing for a livelihood, and, as a consequence, he achieved all the more as a painter. Even the painter must have shelter and board; metaphysics contains no proteins or carbohydrates.

The art world is a frenetically political one. It is no accident that extremely publicized painters are found in consort with a magazine art editor, with eminent critics, with museum personnel, with moneyed collectors.

More often than not, the most publicized painters are really among the best painters. Of course, their talent has brought about their rapport with the art editor, art critic, museum person, and art collector. But I have a notion that the aura of success that envelops such lucky painters because of this relationship helps them maintain a psychic posture abetting high-level output, for in painting—as in other areas of endeavor—success spells out further success.

Painters can carry a chip on their shoulders, an "I'll–show–'em" attitude, for only so long a time. Bolstered by the egotism of youth, painters can work hard in the assumption that when they break through to a personal image it will be given great attention. But what if there is no break-through, or what if the painters break through and no one pays it mind?

Painters have ego. Painters' egos are intimately tied into their expression. The process of painting involves the creators physically, viscerally, intellectually, and emotionally. The root person is exposed, whenever and wherever his or her works are exhibited. To fail as an exhibitor is frequently devastating to the painter's ego. Critical attacks can result in a paralysis of creative will.

Painters quit their art when saddled with the responsibilities of a family. They are forced to accept an opportunity to engage in a business, to sell insurance or cars; to in some way earn money (a successful physician told me he'd once chosen between medicine and art and had made the wrong choice).

Finally, some quit to move into a peripheral position as art critic, art historian, art administrator, or museum employee. They do this after having recognized that their direct contribution did not measure up to the contest.

While they hold good jobs as art teachers, there are many who remain as painters who have developed high powers of rationalization to support weak efforts as artists.

31.
Against Our Death*

Against the day of our death, we create our painted screens. We live and labor in continual hope that our art will live on. We strive with our utmost might to beget that good work that will assure us immortality. Yet we carry hidden in the recesses of our minds the unadmitted knowledge that at its permanent best our work will become mold in a few generations.

The painter's art sometimes offers bitter imagery, acknowledgment of man's helplessness at the edge of the void; our art signifies the painter's defiance as we tread the brink of that awful maw, the empty pit on the other side of our dying. And yet, even as our art becomes emblematic of the painter's awareness, yes, even while heralding our concern, it becomes a screen hiding the awesome deep from the painter, hiding the truth of the reality of the finality of the end, of the everlasting nothingness awaiting us, and the truth of the terrifying indifference of the universe to what man is and is about.

The painter's art becomes a protective wall even though decorated with symbols of men's trials and with banners dramatically pronouncing the nature of our ultimate fate. For so ordered is the human mind that shadows become reality, and it is upon that psychological fact art is based. The

*Hiram Williams, "Of Art and the Painter," *The Graduate Journal*, (Austin, Texas: The University of Texas at Austin, 1968), Vol. VIII, No. 1, unpaged.

painter's work of art takes on a guise of permanence, of foreverness, and poses as an absolute thing—a something to last seasons of eternities. The painter rejoices before the work while it is in the making and is gladdened upon its successful completion, for we now have another sign that will last forever. You may well ask the question, "How does the work of art fool the painter into thinking it eternal?" The response is excessively simple— the work of art achieves unity during the painter's processing of the picture as it takes on that look that nothing in it can be added, subtracted, or changed, ever.

The formal side of the work of art: How is it made? How constructed? How the stressing of its tensions? Its image? Its plastique? How its form? These are questions stirring the viewer's mind as he or she directs attention toward the work of art.

What of the artist? How his or her life? The painter's thought? What molded the painter? The viewer frequently wonders about the artist. Is the artist fake, or is the artist shaman? Is the artist magician, or is the artist a prophet?

The shadows on the painted screens (or should I say apparitions?) are made in their own time, made by people trained in the techniques of the painter's craft. Painters are persons who are sensitive enough to the currents that converge upon them to cause the creation of a new, significant art which is, after all, born from the old. And just as a baby is born new into the world and is different because of difference in combination of chromosomes, so a work of art is born because good artists represent different individuals whose stance is in a certain place in art history, as they are surrounded by a certain group of men and women at a particular moment in time. I am trying to say that just as the child cannot help to fashion its being, just so is the condition of the artist a product of factors beyond personal control, and, of course, our art is the sign of this.

It is interesting the public response to the death of a creative artist. Critical comment will ordinarily tend to ignore the death and center upon the artist's work. This is as it should be, I hear you say, but it seems to me that by and large the artist is ignored so that haste may be made to keep the reality of the shadows clearly in sight. The abyss must be kept at the periphery of vision if it cannot be kept beyond. It is interesting, too, that the deceased artist in any area of the arts is spoken and written about as though alive—alive in the artist's works. The public treats them so, for they must. Treat the artist as if dead and they come too close to the pit.

So they treat the artist as a singular individual at a certain point in the history of art and admit to the reality of the shadows upon painted screens; painters do in their lifetimes. Perhaps it is enough that the viewers of art do this, also.

And it may be that our viewers cannot help themselves for it appears clear to me that men and women best think and best feel by virtue of meta-

phors. It appears that it is by looking into the mirror, at the shadows, at the apparitional images, we find our truths. We can accept final truths in this way, by indirection. Stark, statistical truths are difficult to believe; they are so shocking, so replete with evil portent. The future, our very own future, brightly lit, cannot be faced to be seen in its clearly ominous detail. The art public accepts the metaphor. They experience it as art. They examine the work of art in every particle, and if they despise it, they dismiss the artist, dead or alive, saying "the work of art is all that counts." If they like the work of art, they speak of the artist as though alive and among them.

They ask of the painter and we painters ask of ourselves that we be original. This is so because the painter's apparitions must be for life and against death. Unoriginality cannot exist eternally, for it has no identity. The original work has identity and represents singularity and above all the unity of a consciousness. The abyss does not tolerate consciousness; hence, the work of art must exhibit consciousness par excellence to better hide the void.

Some viewers ask that the work of art be of a tragic nature. If the work of art is tragic, these viewers delight in this, for through the shadows they can lean over the lips of the crater without danger. It must be understood that in part artists flirt with disaster as we create the apparitions, and perhaps the public understands that we experience the void while completely alive in the exercise of our talent, alive as we use our skills, alive as we pillage our creative resources. Oh, how beautiful is life when compared to death dimly glimpsed!

Other viewers do not want to understand the work of modern art at all. They go to art to be mystified. They ask that work of art to imply the void, to be an enchanted place, and it is at this point certain art takes on the guise of an altar piece symbolizing a religion.

And there are viewers who recoil in horror from the work of modern art. Artists, in flirting with the deep, have revealed too much, perhaps more than even they knew. The artist's surrogate for the void must not attempt to unveil even fragmentally the actual abyss, they feel. The viewer is not to be made anxious.

But when through art, the artist comes too close to the pit, the recourse is suicide. I apologize beforehand for speaking in paradox. de Staël, Pollock, and Maurier—all suicides—came to a time in their art when art failed them, which is to say, they failed art. The horror of complete creative failure is so kindred to the horror of death that a bridge is made to actual death. When the void encroaches upon life, it so darkens the crater's lips that the imperiled step over almost unknowingly. There is real danger in practicing art.

32.

A Portfolio of Some Fellow Painters

There are many painters. Good or bad, the ones I admire are those who have kept the faith, often while facing difficult survival.

Michael Kemp, landscapist, sleeps in a tent and paints in the parlor of a decrepit frame house. He teaches fiddle playing, does chores, and performs other onerous tasks to stock his larder. Mike confronts the world with a wry grin.

Steve Moore and Bill Shirley, accomplished painters, have hacked for years to keep body and soul together. Bill Schaaf and Paul Fullerton have accepted one-year appointments at a number of institutions to be associated with employment congenial with their creative activity.

Painters of the caliber of Harry Bliss, Lewis Harris, George Bartko, Henry Fagen, Mickey Kaplan, Allen Novak, Claude Ponsot, Dwight Rieke, Robert Tieman, Lance Richbourg, George Zoretich, Jim Sajovic, Bob Beach, Peter Bodner, and others I know, all remain deeply immersed in their crafts even though the New York art scene has given them minimum attention.

George Zoretich teaches graduate painting. Claude Ponsot teaches, George Bartko teaches. Susan Sorrentino works in a department store. Liz Indianos is a mother and housewife. Each of them paints and will continue, come hell or high water, but each of them would give their eye teeth to have the opportunity to paint full time.

"Leonard Kesl"

"Lenny Kesl"

"Levi Kytael"

He startles one on first encounter. He fascinates. He is charismatic to some; art students and odd characters cluster about him; they cannot get enough of him.

One has the impression that his eyes rotate in concentric circles. A Joe E. Brown, "Popeye the Sailor," mouth stretches and twists, twines and turns, as elastic as rubber under those congolese nostrils. Thin sandy hair forms a sparse patch between the red of seemingly permanently frostbitten ears set outside the squirming of two tireless mobile cheeks.

A long, corrugated neck, a lean sometimes tanned, sometimes sun-baked, sometimes splotched and pale torso—sandwiched between dangling arms—complete the assemblage from the navel upward. From the navel down extending toward the ground is as equally a fanciful sight, for a great buckle attached to a leather belt supports shorts that fall in Victorian curtain folds to knobby knees which are above calves of amazing girth. Workman's shoes toe out like a gander's paddle feet as Leonard Kesl walks, something Leonard Kesl seldom does, however. Mostly Leonard Kesl gyrates bouncing, darting, moving spastically with disordered purpose. I once observed that he'd made five disparate gestures while going from a standing position through a portal six feet away.

My doorbell rings. I open the door. Lenny has pushed the bell and sprung backward into my yard. Wheat germ drips from a spoon. Lenny has a genius for good health. His bowl is clutched in both palms like an Indian beggar pleading for alms.

Have I been working? Yes. He'd like to see my latest painting. Will he want to trade? I think. The last time he got the better of the bargain. I had better be wary. Better watch out. Be alert. Of course, I had bettered him a time or two!

Leonard Kesl is a veteran and inveterate collector. He collects my stuff, Bodnar's stuff. He cons; he trades. His walls are plastered with art of all kinds, from everywhere. Good art, too. Lenny has a discriminating eye. Some things were given to him as tokens of affection, of love. He has several Joseph Cornell collages.

Leonard Kesl went to Florida from Alaska talking of parkas and moose. He brought crates of his own paintings with him. Hundreds of his own paintings in crates. They were stored in the carport. The crates were opened in their own time and some pictures flowed into his bedroom, into the dining room, into the living room, then down the hall toward the bathroom to direct and pour into his daughter Diana's room and son Jim's room. Lenny converted the carport into a studio, but this was not enough. He was forced to build a twenty-by-forty-foot floor space. He hoped to have room to work, "an inner sanctum," he said. The inner sanctum became a storage area. Tides continue to flow. There is no ebb. The paintings pile higher each day. There will be no end to the flood in our lifetimes.

Shelves line walls—books and brochures. Len is parsimonious to a fault but will break his bank account to buy an art book he wants, something on Schwitters, Nolde, or Kirchner; something on Soutine. He is invited to lecture on Soutine. It is a wonderfully informed talk, a remarkable talk.

Leonard's collection of brochures from art exhibitions runs into hundreds. He writes letters to galleries using a large childlike scrawl. They respond by sending him their literature season after season, year after year. Can't believe it!

He goes to each important movie twice so he may memorize it. Len never forgets the slightest detail of a movie he has studied. His record collection is comprehensive. All jazz. Leonard Kesl is a jazz buff. He knows the history of jazz, the names of jazz musicians and composers; all the pertinent dates and places are familiar to him. Buffs delight to exhibit their special knowledge. Lenny's no exception.

He has sung professionally. His voice has that throat quaver affected by jazzy singers, a kind of gargling. He sings even today at "Lillian's," his right hand cupped to his right ear as he listens to himself. He is very popular.

He plays the drums, lambasting their skins with manic energy. He can play for hours. He can sing for hours. He can paint for hours. He can socialize for hours—but he will not mow the lawn for longer than fifteen minutes at a time, too much work.

Wrote this on the occasion of a one-man exhibition of Leonard's at the Worthington Gallery, Chicago, and it was run in *Midwest Art,* November, 1977.

Mernet Larsen visits. She has spent the year painting in New York and teaching at Yale and in Montana.

Mernet Larsen told me I knew more of New York art gossip than she did. She spent her time indoors painting. She told me that when out alone at night she sometimes disguised herself as an elderly, poverty-stricken woman. She hoped, by this strategy, to suggest an unlikely target to muggers. I've seen her work, oil on paper, in her Tampa studio. Panoramas of the lower East Side, interiors and exteriors, densely populated with people; descriptive imagery of personae living among vistas of unexpected dimensions, unexpected optical behavior. Everywhere are surfaces of sheer paint. I could live the balance of my life with any one of those paintings (Figure 32.1).

Mernet and I reminisce and our memories invariably turn to Steve Lotz. Lotz is a tall, slender man. I am quite short. Once we were talking, my head at Steve's chest level, when, as he peered over me, his china blue eyes virtually popped. A fellow came by who was looking down on Steve. A new experience for Steve but not one to be translated into art.

Figure 32.1
MERNET LARSEN
Park oil on paper, 72″ × 90″, 1975
Collection of the artist.

Figure 32.2
STEVE LOTZ
Plant Goddess IV Prismacolor and
spray paint, 32″ × 32″, 1978
Collection of the artist.

Steve Lotz hosted a party in a junkyard, made a vat of medical alcohol punch, and invited all to attend in formal dress. He invited local dignitaries, and they went. A splendid party and memorable; remembered as the best party most had ever attended. The closed lids of porcelain commodes make splendid congo drums.

Steve Lotz is engrossed in Jungian psychology. His art is a reflection of this, phallae twine jungle-like over and about nude couples. Steve and his wife, Gretchen, are summer residents on a property at Lake Atitlan, Guatemala, and a large quantity of Steve's art is a reflection of all of this (Figures 32.2 through 32.5). No doubt Jake Fernandez and his wife Linda

Figure 32.3
STEVE LOTZ
Passage Prismacolor and spray paint, 32″ × 32″, 1974
Collection of the artist.

Figure 32.4
STEVE LOTZ
Plant Spiral Prismacolor and spray
paint, 32″ × 32″, 1974
Collection of the artist.

Figure 32.5
STEVE LOTZ
Spiral in the Garden Prismacolor and
spray paint, 32″ × 32″, 1976
Collection of the artist.

Figure 32.6
CARTER OSTERBIND III
Bicycle Still Life oil, 60 × 48″, 1978
Collection of the artist.

Carter Osterbind once majored in English literature but now paints after six years as a naval officer and service in Vietnamese waters. As a partner in a nursery he has known business success, but he has thrown this to the winds to be a painter. He's a good one and this could answer the question, "Why?"

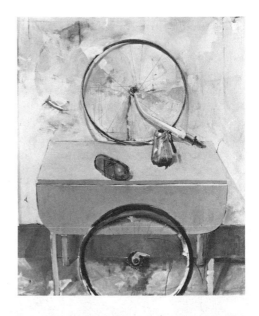

Figure 32.7
MARGARET TOLBERT
Donuts oil, 40″ × 48″, 1977
Collection of the artist.

will continue to paint as he works in the building trades; as she earns wherever and whenever she can.

No doubt Steve Hodges will continue to work in prisons or mental institutions to support his fine visual comments on today's living. Inventive comments. When we have something to say and the means to say it, we painters have no choice but to paint.

Carlos Melian is of Cuban extraction and comes closer to being an "all-American boy" than almost anyone I have met. As a painter, he is a formalist. He eschews description. His enthusiasm for abstraction is infectious.

Figure 32.8
CARLOS MELIAN
Untitled oil on canvas and duct tape, 72″ × 96″, 1978
Collection of the artist.

Figure 32.9
NANCEE CLARK
Seated Figure #1 mixed media on
museum board, 32″ × 40″, 1977
Collection of the artist.

If you met Nancee Clark, you would be
aware of her as an unusually alive per-
son, and shortly you'd find her to be a
creative person. Her art speaks of to-
day's women.

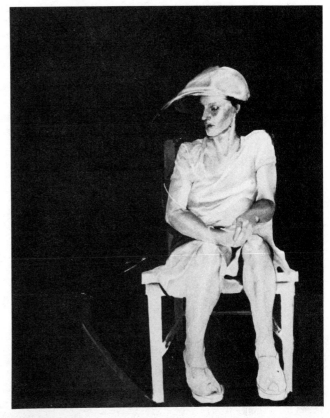

Figure 32.10
LEONARD KESL
Untitled. watercolor and collage,
18″ × 24″, 1975
Collection of the artist.

Leonard Kesl doesn't mow lawns. He
spends his time doing things like this.

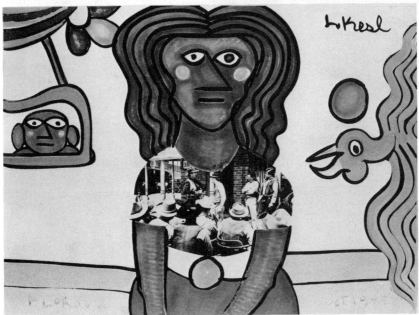

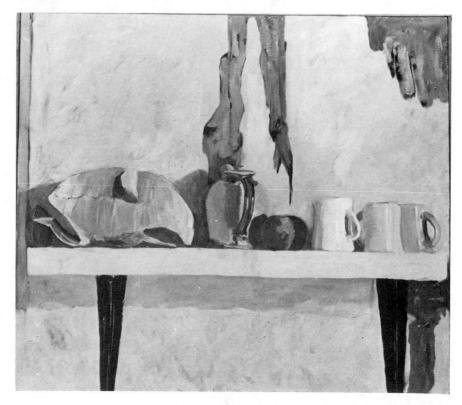

Figure 32.11
MICHAEL KEMP
Still Life on a Shelf oil, 32″ × 36″, 1977
Collection of the artist.

Michael Kemp looks dauntingly radical, but his art declares him to be seriously traditional. Mike's art reminds us that tradition exists.

Figure 32.12
BYRON SLETTEN
Mattoon acrylic, oil, canvas overwood, 40″ × 60″, 1982
Collection of the artist.

Byron Sletten is another devoted formalist. He once painted a series of mid-ocean vistas that looked like water. He has not made that mistake since!

Figure 32.13
NEIL ROSE
Palm oil, 36″ × 42″, 1980
Collection of the artist.

Neil Rose is a Marylander in Florida; therefore, his fresh insight into palms as image.

Figure 32.14
GEORGE BARTKO
Striped Dress oil, 63″ × 70″, 1974
Collection of the artist. Photograph by Leendert Kroesen.

George Bartko escaped under a blanket of bullets from Hungary with his father, mother, and sister; hence his interest in all things American.

Figure 32.15
DENNIS SEARS
Optical Intensity oil, 51″ × 27″, 1982
Collection of the artist.

Huntingdon College in Montgomery is
lucky to have Dennis Sears on its staff.
The man knows how to handle purple
patches!

Figure 32.16
WILLIAM SHIRLEY
Turning Head acrylic on polyester resin layers, 10″ × 12″, 1981
Collection of the artist.

I have had many fine and talented students, but none have had the incredible manual dexterity of William Shirley.

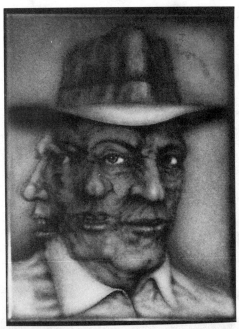

Figure 32.17
LESLIE NEUMANN
The Artist and His Muse oil, 50″ × 52″, 1978
Collection of the artist.

Handsome, tall, and lean, the very picture of a high fashion model, Leslie Neumann lives and paints in New York City intent to rival the 40,000 to 90,000 artists who live there. Miss Neumann is "making it" in New York City.

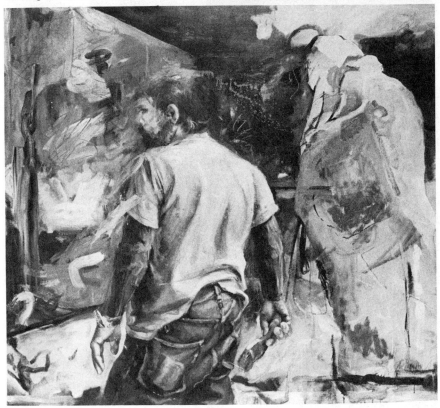

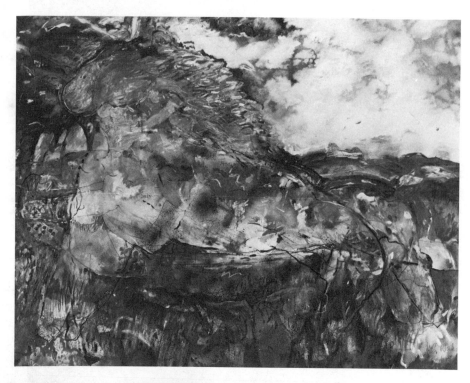

Figure 32.18
WILLIAM SCHAAF
Equestrian Landscape mixed media, 4″ × 6′,
1981
Collection of the artist.

For years William Schaaf has been painting and
drawing a horse-like beast often carrying male
and/or female figures—images depicting a per-
sonal mythology, inventive and poetic in feeling.
William "Bill" Schaaf is an army brat. Does a
young life spent in military installations lead to
ultra-Romanticism?

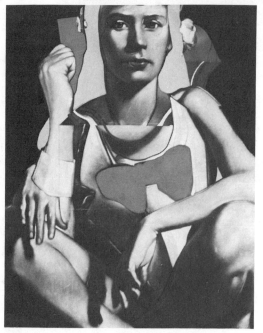

Figure 32.19
ROBERT BEACH
Young Girl acrylic, 60″ × 48″, 1977
Collection of the artist.

I have known Robert Beach for twenty-five years.
Formerly, Bob was a medical illustrator. Today he
paints "time-space" imagery, descriptive, but for-
mal. The discipline of his past pays off in the
present.

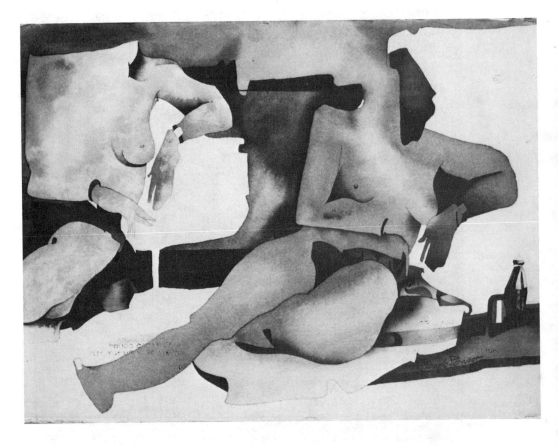

Figure 32.20
CLAUDE PONSOT
Reclining Figure watercolor, 22″ × 30″, 1981
Collection of Asef Kholdani.

I have known Claude Ponsot as long as I have known Robert Beach. Algerian and French, he is, as you would expect, a man vibrant with enthusiasm for this thing called painting. Even so, he has specialized in silk screen printing. His images, like Beach's, are "time-space," which is to say that several views of happenings in several places, and at different times, are incorporated into the image that is a painting.

Figure 32.21
JAMES SAJOVIC
Sherry with Hat acrylic on canvas, 40″ × 40″, 1982
Collection of the artist.

James Sajovic teaches at the Kansas City Art Institute. Jim came to us at the University of Florida from the University of Illinois. He stands out in my mind as an exceptional talent, and he has shown internationally.

Figure 32.22
JERRY CUTLER
Purse Snatch Metope IV oil on canvas,
42″ × 42″, 1982
Collection of the artist.

Another fine young painter—Jerry
Culter. His wife Ada is Mormon. His
children are bright, and he is fulfilling
his promise. What more can life give the
creative person?

Figure 32.23
DON MURRAY
Primavera acrylic, 21″ × 24″, 1979
Collection of the artist.

Want your motorcycle fixed? Advice on
how to sail a boat? Which is the best ten-
speed bike? Ask Don Murray,
abstractionist.

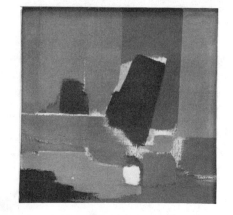

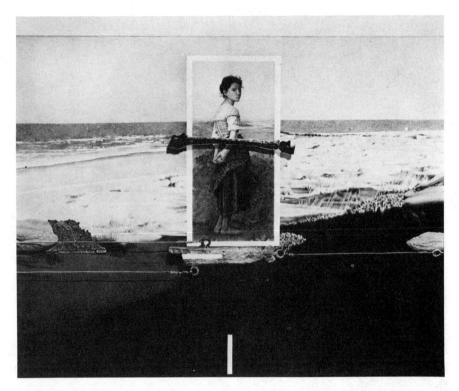

Figure 32.24
JEFFREY KRONSNOBLE
Box IX oil on paper, 40″ × 48″, 1982
Collection of the St. Petersburg Art Museum.
Photograph by Peter Foe Fotoworks.

Jeffrey Kronsnoble makes a small collage
using material from magazines, then
duplicates it in a dry brush technique on
large sheets of paper. The final result is
the illusion of collage but, of course, none
of it is collage. What stunning
craftsmanship!

Figure 32.25
STEVE MOORE
Blue Pyramid oil on panel, 7½″ × 7⅛″,
1982
Courtesy Addison/Riplay Gallery.

It is a crying shame that the illustration
of Steve Moore's painting is not in color.
He can match Van Gogh for brilliance
and intensity.

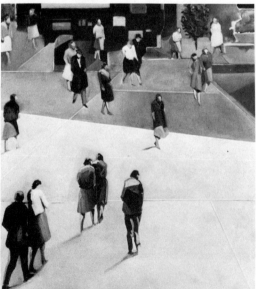

Figure 32.26
WILLIAMS STEPHENS
Summit acrylic, 16″ × 20″, undated
Collection of the artist.

There is so much I would like to say about William
Stephens, about his devotion to art and to art
teaching. Bill approaches his middle years and con-
tinues to grow. None of us can do more than that.

Figure 32.27
ENRIQUE MONTENEGRO
Pedestrians in Shopping Mall oil, 60″ × 50″,
1980
Collection of the artist.

I wrote about Enrique Montenegro in the original
Notes for a Beginning Artist. Enrique continues to
fulfill the expectations that I and others had for
him.

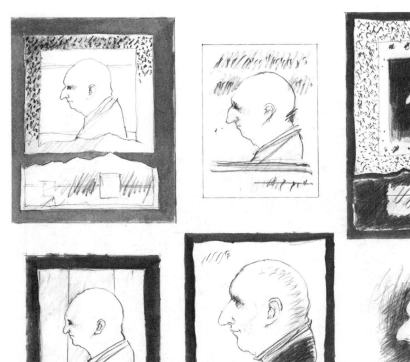

Figure 32.28
KENNETH KERSLAKE
A page of sketches.

One of my favorite people and a favorite artist,
Kenneth Kerslake is primarily a printmaker after
spending time as a painter. He has returned to
painting. In time he will eclipse many, if not most
of us.

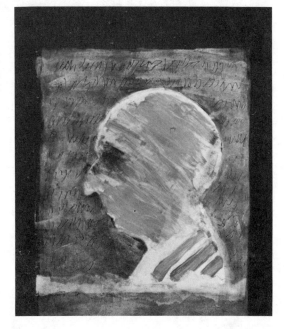

Figure 32.29
KENNETH KERSLAKE
Profile oil on paper, 24″ × 18″, 1983
Collection of the artist.
Photograph by Kenneth Kerslake.

Figure 32.30
MICKEY KAPLAN
A Day in the Life mixed media, 60″ × 72″, 1980
Collection of the artist.

Mickey Kaplan is one of the most enterprising studio talents I know. These days he is in California operating a gallery mostly for the sale of his own work. Mickey could survive anywhere.

Figure 32.31
WILLIAM KORTLANDER
Ridge Side acrylic, 48″ × 72″, 1982
Courtesy Haber/Theodore Gallery, New York.

William Kortlander holds the Doctor of Philosophy degree in art history from the University of Iowa. Even so he paints well enough to be shown with the likes of Fairfield Porter. He is an authority on the use of acrylics.

Figure 32.32
GRETCHEN EBERSOLE
A Breeze to Cool the Night oil and
acrylic, 42″ × 44″, 1983
Collection of the artist.

Gretchen Ebersole is a housewife in
Jacksonville, Florida. She is also an art
teachers and has taught in both public
schools and in college. As you see, she
paints well and exhibits in shows through-
out the southeast.

Figure 32.33
JOAN DAVIDOW
Kirman Series #3 oil, 40″ × 48″, 1980
Collection of the artist.

A mother and housewife, a fashion model
and sometimes television personality, Joan
Davidow manages to find time to paint por-
traits of her sons and others close to her.

33.
The Corcoran Piece

The biennials were inaugurated in 1908. The catalog of *The Third Exhibition of Oil Paintings by Contemporary American Artists,* at the Corcoran Gallery of Art, Washington, D.C., tells us that more than one million people attended the first two shows and that forty-seven paintings were sold, aggregating more than $97,000. Twenty-one of those paintings were purchased for the permanent collection of the Corcoran Gallery. First prize (and the Corcoran Gold Medal) was awarded to Edmund C. Tarbell, and second prize (and the silver medal) was awarded to Gari Melchors. Third prize (and the bronze medal) was awarded to Childe Hassam for his painting titled "Springtime." Daniel Garler was in the show. Jonas Lie was in the show. Alden Weir was in the show. Robert Henri was in the show. Frank Duvenach was in the show. John Singer Sargent, Mary Cassatt, Charles W. Hawthorne, William Chase, and Dwight Tryon were in the show. So were Leon Mayvis, J.J. Shannon, Morris Hall Pancoast, Marjorie Ellen Watmough, Carlton Wiggins, Cecilia Beaux—oh, where are they now? Where are they all now?

Something terrible must have happened between 1910 and 1912. In the catalog of the fourth exhibition we read: "To all the artists whose work we have the honor of showing, the Committee *begs** to tender its most cordial thanks for their contributions and for the same indispensable support which they have so freely given.

*Author's italics.

"The Gallery entertains the confident hope that the exhibition will be received by the public with the same enthusiastic interest that has characterized our former exhibitions." Do you observe how their confidence has waned?

Yet by the time of the sixth exhibition, the Corcoran had brought fifty-two paintings; $264,710 had purchased the one hundred fifty-seven pictures sold.

Senator William A. Clark each year donated $5,000 for prizes. His total donation for the six exhibitions totaled $31,000. How, I wonder, did that extra $1,000 slip in? For six times $5,000 is $30,000. The Honorable William A. Clark gives his award to this day via a foundation that I do hope is keeping a better count of it.

The Ninth Exhibition of Contemporary American Oil Painting was held between December 1, 1923, and January 20, 1924. George Bellows won the William A. Clark prize of $2,000. Maurice Pendergast was in the show. So was Walter Ofer. I wonder where Walter is buried today? Or is he? Maybe Walter wanders about telling uninterested people that his *Luncheon at Locust* was catalog number 293 at the Ninth Corcoran. The Public Library of the District of Columbia in reference list number 19, lists *The American Magazine of Art,* catalog number 13:507-14, dated December 1922; *Art and Archeology,* catalog number 16:66-74, dated August 1923; *Fine Arts Journal,* 3:282-3, dated January 1918; and *Century,* 68:654-5, dated August 1904—all having articles about Walter, but I suppose he wanders about telling uninterested people that his *Luncheon at Locust* was catalog number 293 at the Ninth Corcoran. I am not sure why Walter does this. It is just that I have this hunch.

Vago, Van Roekens, Van Soelen, Volk, Vannoh, Wagner, Walker, Walter, Walters, Waugh, Weisz, Wendel, Wetherill, Wheeler, Whitehurst, Wiles, Woodburg, Woodward, Wright and Young—all were in the Tenth Biennial in 1926.

Mock, Moffett, Molarsky, Moore, Mora, Murphy, Musgrove were in the Eleventh Biennial in 1928. So were Leon Kroll, Edward Hopper, John Sloan, Arthur B. Davies, Bernard Karfiol, and Richard S. Merymon. Richard S. Merymon exhibited a painting titled *Portrait of William Montgomery, Esq.* and it was number 288 of the catalog.

Maurice Sterne was awarded the William A. Clark prize and the Corcoran Gold Medal November 30, 1930. Maurice was to be the first American given a one-man exhibition of painting presented at the Museum of Modern Art. Leon Kroll was one of the jurors at this *The Twelfth Exhibition of Contemporary American Oil Painting.* Leon Kroll was on the way toward becoming one of the great political figures in the art world of the thirties.

A painting of Peggy Bacon, the caricaturist, by Alexander Brook, her husband, was number 188 of the catalog at the thirteenth exhibition. It was aptly titled *My Wife.* George Luke was in the show, exhibiting *Woman with*

Black Cat. So was Robert Brackman. I once studied with Robert Brackman, who was a great genius of art. Brackman could paint two or three nude females so that they looked exactly like a still life. His still lifes look like still lifes. Andrew Dasburg was in the exhibition. He was to become the dean of New Mexican painting. He had periods: A cubist period, a Marin period, and other periods. One might call him a period painter, for he must have been trying to put an end to painting, and if the fact were out, maybe he succeeded. Eugene Speicher, Jonas Lie, and Charles Burchfield exhibited in the thirteenth exhibition.

Eugene Speicher was in the fourteenth exhibition. So was Thomas Hart Benton, William J. Glackens and N.C. Wyeth (the father of Andrew Wyeth and illustrator of *Scottish Chiefs*). Julius Block was in the fourteenth. I met Julius Block one time. I tell you this for no other reason than I am name-dropping. Russell Cowles was in the show. I met Russell Cowles, also. Yasua Kuniyoshi was in the show. I saw Kuniyoshi once across the hall at the Art Student's League. I have always been distressed that he gave not the slightest sign that he had seen me.

Richard S. Merymon was the principal of the Corcoran School of Art in 1935. S. Burtis Baker was the vice-principal. Mathilde M. Lersenlung, Eugen Wesiz, and Hans Schuler were the faculty. Agnes Mayo was the secretary. The annual entrance fee was $25. Tuition was free. There were classes in drawing and painting for the antique, life, portrait, figure and still life; sculpture; and composition. Classes were conducted both day and evening. No examination or previous instruction was required. Students could enter at any time. For the prospectus of the school, or for detailed information, persons were to apply to Miss Agnes Mayo, Secretary.

William M. Paxton exhibited eight naked women in The Fifteenth Biennial *Exhibition of Contemporary American Oil Painting.* A naked man walking out of a surf has shocked the hell out of them, and they're running around wildly looking for clothes some sneak must have removed. Edward Hopper won the $2,000 W.A. Clark award accompanied by the Corcoran Gold Medal. Robert Brackman showed something called *A Muse;* poor thing has had her clothes stolen. Leon Kroll's nude has had her clothes stolen but obviously doesn't give a damn. John Sloan's nude is a mess, absolutely covered with paint which, of course, destroyed her nudity.

The Sixteenth Biennial Exhibition of Contemporary Oil Painting opened March 26, 1939 and closed on May 7. Franklin C. Watkins who taught at the Pennsylvania Academy of Fine Art won the W.A. Clark prize of $2,000 and the Corcoran Gold Medal. Robert Philipp, who taught at the Art Students League, won the Silver Medal. That year the members of the Board of Trustees were:

C. Powell Minningbrode	Charles C. Glover, Jr.
George E. Hamilton	R. M. Kauffmann
Robert U. Fleming	John Oliver LaFarge

Corcoran Thom John Spalding Flannery
John H. Hall, Jr.

Hamilton was president. Thom was the vice-president, Glover the second vice-president, Minningbrode was secretary, and Robert U. Fleming was the treasurer.

Julian Levi and Hobson Pittman were represented in the Seventeenth Corcoran of 1941. The Seventeenth Corcoran hung all of my contemporary heroes: Henry Varnum Poor, Waldo Pierce, Luigi Lucioni, Kuniyoshi, Leon Kroll, Bernard Karfiol, Edward Hopper, Karl Knotts, Alexander Brook, Arnold Blanch, William Gropper, Milton Avery, George Biddle, George Grooz, Walter Stuempfig, Ernest Fiene, Guy Pene DuBois, Gladys Rockmore Davis, John Stuart Curry, Nicolai Cikovsky, and John Carroll.

The Eighteenth Biennial Exhibition of Contemporary American Oil Painting had a very thin catalog. In 1943 there was a war on and this meant a paper shortage. The paintings were titled *Landscape; Roosters; A Man and His Dog; Sunlit Fields; Girl with Dog; Horses, Heat and Haydust;* and *The Old Maple.* Obviously, artists were either not interested or were trying to forget the holocaust. At least they were painting. At this time I was running around Fort Belvoir yelling commands at the top of my lungs. In those days my voice was in superb shape, so they made an officer of me.

The catalog was even thinner in 1945. Reginald Marsh won first with *Strip Tease in New Jersey.* Zsissly won second, although he had changed his name from "Albright" to be last in the catalogs.

In 1947 prices for oil paintings were still low: $350, $750, $400, $600, $250. Guy Pene DuBois asked $1,000 and Pricilla Roberts was out of her mind—she asked $2,500. In 1947 you could have gotten a first rate Peter Blume for $1,500.

By the twenty-first Corcoran in 1949 "College Art Cubism" dominated art imagery. Modern art was here! Everyone began to place colored grids over their regional images. No one knew what they were doing in those days, but one understands that a new word was spreading. By 1951 semi-abstractions were on the scene and numbers of surreal pieces appeared. Kurt Seligmann, Henry Koerner, and Eugene Berman were in the show. So were Ben Shahn and Philip Evergood, who won second prize.

Abraham Rattner was first in 1953 at the twenty-third exhibition; Hobson Pittman won second; Frances Chapin third; and William Congdon, fourth. Second and third prizes were won by Fritz Glainer and Josef Albers, respectively, at the twenty-fifth biennial in 1957. Abstraction by this time was taking over art.

By 1959 abstract-expressionism was "in" with George Ratkai, Hedda Steine, David Shapiro, Theodore Stamos, Jon Schueler, Jack Youngerman, Adjai Yunkers, Jack Tworkas, Joan Mitchell, and others of the movement.

Hermann Warner Williams, Jr., wrote a foreword: "The Biennial," he wrote, "entering its second half-century, is true to its established tradition in most respects. There is an invited section consisting of one hundred thirty-four works, and a juried section in which only fifty–three works— out of some 1,600 submitted—are included." He further wrote that "ninety-seven percent of the works submitted were not found worthy of inclusion."

Lee Gatch won the first W. A. Clark prize with a collage called *The Beach*. This was the twenty-seventh biennial in 1961. A youngster from the Pennsylvania Academy of Fine Art, Ben Kamihira, won the second W. A. Clark prize. I tell you of this, mostly because I happen to know of it.

The Twenty-Eighth Biennial Exhibition in 1963 was important largely because a painting of mine called *Three Women* was catalog number 140. Another of mine, *Scurrying Theologian*, was in the 1965 biennial, but I have lost the number, a hint that obscurity awaits even me!

34.
Exhibiting

Recently, a talented graduate student came to me in a most doleful mood. He had come upon evidence of collusion between a show winner and a member of the jury. His query was, "What is the use? Suppose one does work hard in complete integrity. What is to assure one that dishonest practices will not do one in?" The answer is that the painter has no insurance against many odious practices evident from time to time to those who deal in the field of art. But the fault is not the fault of art; it is the fault of people in art. If you will refuse to cheapen your art by slanting it toward specific juries, if later you as a jurist will refuse to give prize money to an inferior painting because of some vested interest, if—in short—you insist upon honesty at all times, art will eventually reward you. For, when all is said and done, all you have of art lies in the rapport between you and your painting.

Still, we are careerists. There is a measure of success to be attained that lies outside our studios. I will try to outline in general what might be called a path of progression from local showing to national acceptance. We must understand that an important show might be entered by a "Sunday" painter. It has happened, for, after all, anyone can obtain and fill in forms and send in a painting to a jury. And who knows what some juries will accept?

A frequent tragedy for art teachers comes about when one of their students wins a prize while the teacher's work is rejected. It is possible

that some students paint better than do their teachers. More frequently, I would say, both the student and the teacher have been victimized as the result of a fluke.

Prize-winning can be dangerous, harmful to an ego, inflationary. It takes well-balanced students to retain their sense of proportion in the face of success as prize-winners. I have even known university art students to acquire inflated egos because they have been granted a string of high grades. They would do better to take such successes in stride, as small happenings.

There is no reason why mentally well-balanced young painters should not exhibit, but they must remember that there is danger in being discovered before they have a firm understanding of their own vision, of their own metaphor. In recent years young painters have been pushed all the way to national success on the strength of too limited vision, on the strength of difference supplied by gimmicks. This is too bad. They have a brief day in the sun and are eclipsed before nightfall.

The only real way is to paint until a genuine and new metaphor has been fully understood—its images, laws, future possibilities—then make the move into the public domain. What is this domain?

Almost all regions of the United States are loosely organized in much the same way. Locally an art organization exists, an art center, an art club, a small museum, a gallery or two. Show at these places while finding yourself. The competition will not be punishing, but it is good to see your painting on strange walls and in strange company. When your work easily holds its own in modest company, begin submitting to regional exhibitions. If your work is rejected, go see the show and try to determine the reason for the selections. Was the jury biased in favor of one school over another? Or, was your painting simply inferior to the company you had asked that it share? Be honest with yourself. If, for good reasons, you truly doubt the verdict of the jurists, laugh them off. Keep trying until you hit regionals regularly. By this time local newspaper critics will have an eye on you. By this time perhaps a local museum director will have an eye on you. You can begin to hope that someone in the art field who writes about it will take particular interest in you and say so in print.

Years ago I wrote with confidence that breaking into national exhibitions would lead to a New York gallery for I said "create that good work, that truly substantial metaphor, and the art world will beat a path to your door." At the time this seemed to be true, but I no longer think so. First-rate work can and is being ignored. Furthermore, the great national shows no longer exist. The cost of freight, of stockroom handling, and of insurance finally made them unfeasible. The prestigious Pennsylvania Academy of Art show folded. The Corcoran Gallery, Whitney and other annuals became essentially regional or local shows. The Pittsburgh International ceased the annual group exhibition. It is now extremely difficult for hinterland talent to gain national visibility.

For a period I enjoyed national attention; via national exhibitions I came into notice. This was no surprise to me. I had expected as much. Invitations to shows, invitations from galleries to become a member of their stables were everyday occurrences. I had a strong supporter in the Museum of Modern Art, New York, in the Whitney Museum of American Art, at the Corcoran Gallery, and in Pittsburgh. The then-head of the American Federation of Art supported me. I had a friend on the staff of a major art magazine. Truth is, I had it made. But then the people at the Museum of Modern Art and at the Corcoran retired. The person at the Whitney left New York City. The Pittsburgh and magazine supporters died, while my AFA champion changed jobs. Then I knew why so many good things had been coming my way, for most of the attention ended abruptly. I went from rags to riches and from riches to rags in something under two and one-half years.

Both the person at the Modern and the person at the magazine had troubled themselves to try to persuade me to move to New York. I argued that I could paint as well in the hinterlands as in New York, maybe better; for in New York, influences would beset my output. They knew something that I did not and that was that a "star system" had appeared. This meant personal presence on the art scene was necessary to further a painter's career. The charismatic urbanites were beginning to have their day. "In" groups were forming that included a critic or two. Some dealers were in; others were out. It was of utmost importance to have the right dealer. Artists, critics, collectors, and even museum personnel partied and were in frequent contact with one another. This is so today.

Gene Baro once said to a group of my students that "all artists are whores." Small wonder! The system requires pandering to break into it. Baro told me that a prominent painter planted articles in art magazines, testimonies to his greatness. I said naively, "Does everyone know this?" "Certainly." "Then why is he permitted to get away with it?" "It's a conspiracy of taste," was the reply. In other words, there was mutual agreement that this was an "in" artist.

Larry Rivers, Robert Rauschenberg, and others made use of public relations people years ago. I knew of this and had read about it, but I did nothing. They understood our times better than I did.

In the past students of mine have gone to New York to "make it;" several of them are there now. None have made it in a big way but remain, for the city has an energy that holds out promise that tomorrow will be better. The city creates the illusion that what happens in Manhattan counts; nothing counts elsewhere.

Art centers such as Atlanta, Washington, D.C., Dallas, Chicago, Los Angeles, and Sante Fe don't agree.

35.

An Opinion

Between the two Great Wars there was unanimous agreement that Paris was the center for the art of painting. Concerted opinion selected Braque and Picasso as the top-drawer talents. Press and market combined effort to form an industry that elevated the prestige of these two along with others—Miro, Chagall, Leger—and the value of their art to unprecedented notoriety and unprecedented monetary sums.

Young American painters of the 1920s and 1930s chased off to Paris (or dreamt of chasing off to Paris), or reacted against Paris, to entrench their images in a regional realism after the examples of Thomas Hart Benton, Curry, and Wood. In either event, Paris dictated the choice. But that was between the wars.

Following World War II numbers of veterans remained behind to study or to work in Paris, then the art capital of the world, unaware that the art center was shifting to the United States, to New York City. For in New York, under the influence of European artists dislocated by the war, a group of artists were formulating new styles in art. A press and market were beginning to take shape which would challenge the hegemony of the French and eventually cause American art to achieve dominance over the world art scene. This domination would continue through the 1950s and into the 1960s, at which time London art activity attracted so much attention that it began to rival New York as a center.

In recent years other civic centers in the United States have made some effort to acquire status as national art centers, and of these perhaps Los Angeles has been most successful.

A consensus agrees that the world art scene must be located in New York City—the entire scene: artist creating, museum and gallery exhibiting, and marketing. The consensus has agreed that any art activity outside the city is questionable. Hordes of painters agree to this. I have no idea of how many thousands of painters are in New York, but the number must be legion. Twenty years ago there were five hundred Japanese painters alone. I wonder how many Iowans or Kansans there are. I wonder how many Philadelphians there are.

Kovler Gallery of Chicago gave me a show. Mrs. Kovler was distressed opening night because the weather was the worst of the season and attendance was small. I sensed, however, that a deeper source of her frustration was her recognition that wealthy Chicagoans flew off to New York to buy the same art they could have bought at home at her gallery. On this same trip I discovered that I was much envied by local artists, not because of my work, but because I had a gallery in New York. Their questions centered upon one theme: How does one get a New York gallery?

I have visited the University of Illinois, Ohio State University, and others and have found artists asking the same question. Those art faculty members who have acquired New York galleries are acknowledged to be successful artists. Many of the unattached spend their holidays in junkets to New York where they charge from gallery to gallery making fervent pleas that someone look at their slides. It makes for joyless vacations.

Two faculty painters who I know gave up excellent teaching posts— salaries and benefits—sold their homes and settled in dreary Greenwich Village lofts so they might be on the scene in New York. In each case their wives divorced them.

I must admit that most of the artists that I respect are in New York. Much of the better talent in the land has bought the thesis that to succeed in art one must be there. However, I think that it could be a fine thing for art, if artists got out of the city. I think that it would be a fine thing for artists if they would stop looking at one anothers' efforts and spend more time looking to their own. I think that it would be a fine thing for art if artists outside of New York would ignore art magazines that convey, amid trumpet and bombast, what those on the scene are doing. Emulation of styles formulated in New York reinforces the idea that art must emanate from New York. Out of town artists should have more pride.

I think it would be a fine thing for art if critics would look at individual artists and not at movements and would be unsympathetic to bandwagons (I talked to a critic who admitted no interest in individuals but, as he put it, was tremendously excited by group activities). I also think that it would be a fine thing if critics would stop shaping the course of art. They do this all of the time by the nature of the encouragement they give along with damnation. Some of them are flagrant in their intent to lead artists rather than let artists lead them.

36.
Of Art Students

In my sixth year I was pushed out a Sunday school window. My skull was fractured upon impact with the sidewalk eight feet below. During recovery, an older boy, John Morse, later an editor of art magazines and sometime director of Winterthur Museum, taught me to draw a wolf's head and a horse's head. My career as an artist had begun.

A couple of years later I sat Saturday mornings in an art class taught by eighty-three-year-old Mrs. Luce, who wore lace at her throat, had a fifty-year-old paralyzed son upstairs, and painted huge canvases depicting roses. Mrs. Luce had a book of Ingres' reproductions that contained *La Source*, a seventeen-year-old nude girl pouring a jug of water from atop a shoulder. This reproduction caused me to fall in love with art.

My art training continued during the depression years; through the late 1930s I pedaled my bike twenty miles each way twice a week to study with an art teacher who was paid $90 a month under the National Recovery Act to teach local talent.

The instructor was a wispy little man who sported a white artist's smock and a conspicuous Roman nose. He was a Jehovah's Witness and blamed his large Rubenesque wife for leading him to sin almost daily. She walked about with her great, brown, cowlike eyes rimmed in red from weeping over her guilt.

The man was an absolute vegetarian because of his stomach's antipathy toward meat. As a consequence, he had a wonderful breath, like silage.

I loved to pass five or six feet in front of him and be laved by that aromatic gale. The man knew the true path to God's right hand. He also knew anatomy, and he taught me everything he knew about anatomy; not once did he try to convert me to the Witnesses, and for that I have always been grateful.

Time passed and, following four and one-half years in the Army of the United States and a stint in commercial art, I found myself at the Pennsylvania State University. There I found Hobson Pittman. Now Hobson Pittman had been raised by two maiden aunts near Tarboro, N.C. This experience had stamped his voice with a purling Southern accent and his manner with an air of effeteness that went well with his casual tweeds, white and trimmed hair, and mustache. Only his glorious smile relieved his appearance of world-weariness. The wealthy middle-aged matrons that came from Philadelphia's Rittenhouse Square or Main Line to study with him in the summer sessions were to a woman in love with Hobson's glorious smile. One in particular was named Patsy.

Patsy was rich as hell. This was easy to see, as she had glasses attached to a chain coiling about her ample neck. Patsy had an apple-dumpling face and bosom and even her belly and knees were apple-dumpling. All of this dumpling sat below an enormous, black, broad-brimmed hat heaped with grapes, watermelon rinds, and several flower gardens.

Patsy was always sweaty, and the intricacies of perspective were quite beyond her. Patsy's barns fell over, and she was so bad that her Nittany Mountain, which is only a hump on the ground after all, looked like a degenerated compost heap.

On Friday afternoons, at two o'clock, all of Hobson Pittman's students would sit along the walls of a former agricultural building that had been converted into a classroom painting studio. They awaited his appearance and critique. All week long that talented bunch of art lovers had been trudging to and from the sites of their landscapes. They yearned for Hobson's approval and were in terror of his disapproval.

There was utter silence, like that in the outer office of a dentist. After an interminable length of time Hobson would appear, clipboard clasped against his right breast. His head would be thrown back as if he were sniffing something awful from which he was trying to remove himself. His pale blue eyes would gleam, so ablaze were they with executioner's passion. He would hoist his left buttock atop the single wooden stool that stood before the easel. He would survey the trembling group with eyes narrowed into tiny slits, which would widen as they swept the works of art leaning against an opposite wall.

"Well," he would then say, "ah see once more you've brought in your adominable works, which only with utmost charity can be called art. As I gaze upon these, ah'm brought to the verge of tears!"

Hobson would lift his bottom off the stool and lift his eyes toward the rafters. "When I dwell upon your nerve to think that you dare to attempt to join the pantheon of glorious artists, those divine heroes of our culture, I become lacrymose; to think you have the audacity to attempt to mingle with Cimabue, Giotto, Da Vinci, Raphael, Utrillo, Michaelangelo, Titian, Tintorreto, Veronese, Bruegel, Durer, Holbein, Domenico Theotocopuli, David, Delacroix, Manet, Monet, Rosseau, Millet, Winslow Homer, Innes, Eakins, Van Gogh, Gauguin!"

He would never mention Andrew Wyeth. Andrew Wyeth was a Philadelphia painter, as was Hobson. Hobson hated Andrew Wyeth.

Having exhausted his litany of heroic painters, Hobson would call on Patsy to put her latest piece upon the easel. Sweating like a stuck pig, Patsy would move toward the easel as in a trance, her hat flopping under its burden of gardens. Hobson, having returned bottom to stool, would examine the latest example of ineptitude and pronounce upon it. As he looked at Patsy's work he declared in a weary voice that she had not done a thing about its green hue, that it remained cow-green: "That's the green, Patsy, that flows out of the corners of a cow's mouth as it chews its cud."

Hugo Weber—tall, gangly, Swiss, and a sculptor, talking with a thick German-accented English—was on campus one summer. He taught Bauhaus sculpture, a system of handling clay or plaster that consumed hours of time while creating an illusion that art was being made.

Hugo was very avant-garde. One afternoon I passed Hobson exposing his pink abdomen to the sun while lying with a towel across his face. He heard me and said, "Hiram, dear boy, is that you?" "Yes," I said. "Hiram, dear boy, ah understand that you know Hugo Weber. Can you arrange so ah can meet him?" I looked at his reddening torso and felt sorry for him. Hobson painted still lifes; Hugo was way-out modern. Hugo Weber is going to eat Hobson alive, I thought; I thought I had better warn Hobson about Hugo Weber. I said, "Mr. Pittman, Hugo Weber is terribly avant-garde." Hobson swept the towel off his face, raised up on an elbow, looked up at me, and proclaimed, "Hiram, dear boy! Few people realize it, but ah'm very avant-garde myself!"

The day came when I had as much formal education as I was going to get. This meant that I could teach art in a public school. The high point of that period was the comment of a Miss Draper of the tenth grade, who looked at one of my paintings, put one hand across her mouth, as the other pointed, and squealed, "Tee hee, it looks just like hog guts!"

One summer I directed both the Delaware State Police Camp for Boys on Assowoman Bay and its crafts program. We made more than 500 plaster face masks. Hugo Weber's sculpture program had paid off. Later at Harrington High School, I cast the entire front of a senior boy and every hair on his body transferred to the mold and from thence to the form. I'll bet

up to that time no sculpture on earth had real hair! No one had been nutty enough to use lard instead of Vaseline®.

The University of Southern California acquired my services for a year and the University of Texas at Austin employed me for six years. I began to break into national exhibitions. I also began to learn about survival in the fevered swamps of academe.

I taught advanced painting at the University of California at Los Angeles in the summer of 1959. I had a large class of healthy young men and women—all had bronzed bodies and superwhite teeth. They were without a vestige of talent, which supported my theory that good painters are not complete persons (you recall that Harold Clurman said, "His art is the health of the artist").

Out of the forty or fifty students, only one held promise. He was unhealthy; yet his work was pitiable. Finally I roundly cussed Lance Richburg and roared, "For God's sake, make it ugly!" I had finally become an art teacher! Several years later Lance Richbourg visited me and declared that the turning point in his art came when I berated him. Today Lance teaches in Vermont and shows regularly in New York.

Each March the art faculty reviews portfolios and records of students wishing to enter our studios as candidates for the Master of Fine Arts degree, which is the painter's terminal degree. As the University of Florida entrance requires that students pass the Graduate Record Examination. We have lost a small herd of good studio talents who were unable to cope with the test. As most of you know, painters are neither mathematically minded nor highly verbal. Until recently our college required our people to write a thesis fifty to one hundred plus pages long. I will confess that I wrote six of them almost in entirety and had my hand in on others to such an extent that I almost claim them. Recently we have moved to a creative option that is more realistic for us and that certainly makes us more honest.

Those invited to matriculate appear in September. We are quite selective as to talent, if not to brains. We get students who have developed bloated egos in regard to their artistic capacities. Frequently they make it clear that they feel superior to our art environment as well as to our faculty. Strong ego is a necessary ingredient to talent, but it certainly can raise hob with a teacher/student relationship. Eventually I learned to ignore these newcomers, for I found that one day they turn to me for help—you see, a change of environment invariably causes painters' work to fall off for a period, and they are then transformed in a trice from the hot-shot painters of the senior class into creative clods. I remind myself that shortly I will have them in the palm of my hand.

37.
Teaching Art
in Hallowed Halls

Despite the scarcity of art teaching positions, chances are that sooner or later you will teach. It takes luck, persistance and patience even though you have paid your academic dues and hold both a Bachelor of Fine Arts degree and a Master of Fine Arts degree. Should fate decree your consignment to public school employment, you will find it a bother that you must take supplementary courses in education to earn certification and, later, other courses to maintain certification.

If you teach elementary school you will be fascinated by the progression of children as they develop their art. During the preschool stages of expression children scribble and tell stories about those scribbles. With better motor control they can soon direct the scribbling. Generalized symbols for tree, figure and house are developed. One day children draw a baseline, simply a line struck in a horizontal direction across the paper. This line represents the children's environment. This group of symbols is called a "schemata." The changes a child makes upon stock symbols reveal the meaning of a given experience. You will watch children tell stories in an additive fashion by describing an event as it occurred in time. This they do by repeating a figure or by showing a change from one state to another, so-called time–space drawing. They do "X-ray drawing, not hesitating to remove the wall of a building, the better to reveal the interior. Once I watched a child draw a line about a symbol for a foot. I knew that the child was describing the kinesthetic experience of pulling on a sock.

As children grow older, the schemata become more and more enriched as a testimony to the increased meanings discovered in lived experience. The children grow older and commence to draw descriptively and less symbolically, and in time these pre-adolescent youngsters will have nothing more to do with symbols. Frankly put, they will wish to draw pictures that look photographic, the more so the better. For years these young people have been happy using symbols but now have lost faith in symbolism and desire a representational expression. This is your opportunity to help, to teach perspective and anatomy. If you do not do this, they will quit art.

It's a madhouse! You have supplies of paper, colored and plain, chalk and crayons, wheat paste and string, but somehow not in the volume you need. A large part of your job is to keep supplies in balance, but what balance? You are required to meet two to three sections of each class at least once a week and there are six grades. And then there is middle school, where you will shine with your hard-earned knowledge of art history, perspective, lighting, and anatomy. Somehow, between your fatigue and avoidance of supply forms, supplies are never right. The problem is that you do not feel that a painter of your caliber should be required to fill in supply forms!

The grades are in competition with one another. Mrs. Brown of the third grade is forever pulling you aside to implore you to help make her homeroom more magnificent than Miss Baker's homeroom during the pre-holidays. It's distressing when you happen to like Miss Baker better than Mrs. Brown. It's true Miss Baker tells better risque stories than Mrs. Brown.

The insouciance of the middle school borders on anarchy, so much so that this is accepted as normal. You will contemplate mass murder.

At the senior-high level, you will be confronted by the children who have difficulty adjusting to the traditional school setting. I solved this by locating weaving looms upon which to locate the posteriors of the girls, two tons of building plaster and castaway desks, chairs and tables which, wrapped in chicken wire, provided armatures for free-form sculpture. The boys could not have been happier.

You will be responsible for school posters and the staging for plays. You will work from morning to late afternoon and sometimes evenings. You will lose weight if you do your job.

I have not taught at a community college but have visited. Some, I think, are extensions of public school while a far smaller number present the first two years of a true university education.

Suppose fate targets you for a college or university position, what then? You will find you have moved into a complex situation where your wits and personality will have as much to do with survival as your much vaunted talent.

First of all, it is assumed you know your job. After all, you were chosen from dozens on the basis of your slides, letters of recommendation, and presentation of a vitae replete with high grades plus a cogent page explaining your philosophy. I would advise you that this is only the beginning, for, you see, you have moved in among a group of men and women who have their alliances, their enmities, and their strongly held opinions. Clear evidence that you are, as an artist, better than anyone in sight will not help you. It will be a hindrance.

Exhibiting energy and willingness to serve on committees won't hurt your cause, but it might help. The department will have one to five, six, or seven "splits." How to avoid joining any of the factions becomes a full-time chore.

God help you!

Yet a teaching rank in an American university, the Medici of our time, is the best support for your art and livelihood short of marrying a wealthy widow or widower.

38.
Beginning Painting

You have perused, scanned, read, or studied the preceding pages and I would give a penny for your thoughts. In all honesty, for me to suppose that any word of mine will give any art-bound person pause would be folly on my part. Off and on, over long years of teaching art, young men and women have solicited my advice about their futures as painters. Without exception I have advised them not to enter painting as a career and almost without exception, my advice has been rejected.

I have responded in the negative; for, except for a fortunate few, there is not a consistent livelihood to be gained from sales, and finding an art teaching job has been difficult for at least twenty years. One of the more pitiful insights I have had has been at National Art Association Conferences, as I watched lines of candidates waiting for job interviews and recognized that most of them were not wanted, not now, nor would they be later.

I recall a poignant moment at one of these meetings when I spied a young woman from the Midwest sprawled over her luggage, the picture of dispair as painted by Byrne-Jones or Holman Hunt. Three days earlier she had bounced into the hotel foyer glistening with the lustre of her newly won MFA!

What of those who did not ask or accept my advice? Ten years following graduation one of my former students drives sixty-foot vans. Others are employed in on-again, off-again odd jobs. One has camped in winter to cut expenses. Two or three of the women work in department stores.

In *Notes for a Young Painter,* I explained that many artists work in seasonal jobs as furriers, pari-mutuel machine operators, and so forth, even though a majority hanker after an art teaching position. There is no stopping a person infused with desire to fashion art. I suspect that person is you, therefore, let me profer some advice to you as a beginner.

I maintain that you should keep a sketchbook religiously; for it is in the sketchbook that the painter initiates the painting. It is said of Georges Braque that he forgot a painting once it was completed, that when he traveled from one of his three residences to another he took his sketchbooks, all of them. These books contained his germinal ideas. It was Rene Descartes who said, "I think, hence I am." The practice of keeping a journal wherein notations about art and life are jotted in time may well prove invaluable. I have kept one since 1968, but I wish I had commenced at your age.

There is much you can do for yourself. Constant drawing develops the "thinking hand." Draw from life and nature, don't be overly anxious to be creative, that comes later. Draw caricatures of your friends, not comic images, but look for the most characteristic features of their faces, stances, movements, then ask them to pose again for a serious portrait of figure study. The characteristics you exaggerated in caricature will appear to give expression to your image.

Practice eidetic imagery. Look at blank surfaces and mentally project imagined images onto these surfaces. Eventually you should be able to trace the images. Draw roads and highways, examine landscapes.

Figure 38.1
Roads and Highways.

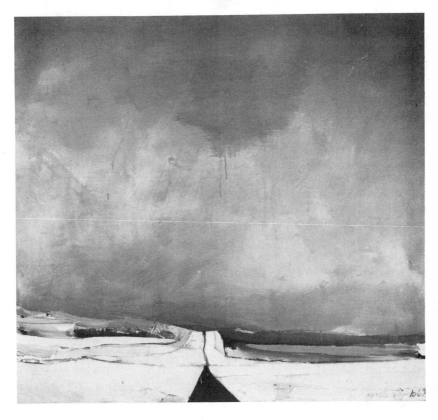

Figure 38.2
HIRAM WILLIAMS
Large Beach Road oil, *72″ × 72″*, 1962–63
Collection of Dr. and Mrs. Robert Marston.
Photograph by L. Vance Shrum.

Where you to confront a natural vista and draw everything before you above, on and below the horizon line, in all liklihood your picture would become a scene. It cannot be called art unless a sense of form pervades the format. (Look at examples.)

It is a good idea then, to draw what you see *below* your eye level. As an example, stand parallel to a sidewalk and place the drawing of the sidewalk at the top of the page, then draw what is between the sidewalk and the toes of your shoes. You will find that this will cause you to see the shapes (or forms) before you. (Figure 38–3).

Drawing interiors works the same way: let the mop board on the far side of a room be at the top of the page, then draw whatever shapes are between it and your feet.

Figure 38.3
Shapes below eye-level.

These exercises should have developed in you a sense for shapes in the vista. Now apply these concepts to the landscape. Here are illustrated four approaches to the same scene (Figure 38.4), and experiments with borders (Figure 38.5).

You've spent time in high school, but most of it was wasted as far as discipline in the visual arts is concerned. Surely your decorations in the yearbook fell short of art, but who cared? You knew perfectly well you must obtain further training. This means more schooling. The apprentice system of the Renaissance no longer exists. What then? Attend a so-called professional art school or attend a university art school? That is the question.

As far as I can ascertain, today there is not much difference between professional art schools and university art departments. The G.I. Bill of World War II was the equalizer. To earn their share of the students funded

Figure 38.5
Experiments with borders.

by the United States government, art schools had to match academic institutions. The difference between them is minimal, although the professional schools will deny this, I am sure. University art departments are roughly the same. Their educational routines can be amusing, for they have a propensity for being *au curant*. When assemblage was out, many art departments recreated their programs in terms of photo–realism.

There are art departments that stand on "fundamentals." I visited one of them and was escorted through the painting studios. In the beginning area, Studio I, students were involved with a problem of how to attach an upper arm to the shoulder. In the next studio, Studio II, I found students involved with how to attach an upper arm to the shoulder. Studio III appeared to be involved with the same problem, and the senior studio, Studio IV, quite obviously had not solved it!

Some departments are very advanced. The latest fad gleaned from art magazines mostly or promulgated by visiting New York artists determines their offerings. Crazes like video–art, concept, and nonconcept art seize the expressive internals of the art faculty and suddenly the campus police are faced with a walking wall, students with arms engaged, walking across the plaza, their hearts enraptured with aesthetic glee.

Art departments can mistake silliness for expression.

What all art departments offer, however, is shoulder-to-shoulder living with others like you, and this can be exhilerating. You learn a lot from one another, as you rub pores, rap, and exhibit egos.

To insert at this juncture the admonition that you spend hours flipping through art books and magazines perusing illustrations, would be näive of me, for you will do this without prompting. I must point out that you will be able to ascertain the period and the artist at a glance. You may not be able to recall the name of the school or date of a period, but you will know the form and its linkage in the stream of forms we call art history. It is through this information that eventually you will know where your imagery stands in relationship to others.

You will develop your heroes of art. This is fine, for by this means you will find where your emotion for form lies. I have my heroes to this day: de Kooning, Giacommetti, Bacon, and Balthus. I happened upon an interview of Jime Dine recently and found his were the same. This did not displease me.

Across the land departments of art have similar programs. At the University of Florida, the studio major takes six credits of English, three of fundamental mathematics, three of behavioral studies, six of social science, nine in the humanities, and six credits in physical science and the biological sciences. These would constitute the general education requirements of your freshman and sophomore years. Beginning Design I and II, Beginning Drawing I and II, and Introduction to Art History I and II constitute the professional requirements.

CURRICULA IN ART

Westin, R.H., Chairman and Adviser; Murray, E.D., Assistant Adviser

The Department of Art offers undergraduate majors in the College of Fine Arts leading to degrees of Bachelor of Arts in Art, Bachelor of Fine Arts, Bachelor of Design and Bachelor of Design in Art Education. Admission to this department is selective. A portfolio of photographic slides or prints of recent art work, including drawing and design projects should be sent directly to the Art Department as part of the application. A return mailer with postage is necessary. For further information concerning these curricula see the Chairman of the Department of Art or the departmental Assistant Adviser.

1. Lower Division Curricula.

Students planning to enter the Department of Arts should take the program listed below. Students are also encouraged to consult with a department adviser for more specific information regarding grade point averages and placement.

FOR THE DEGREES IN ART (GRAPHIC DESIGN, ART EDUCATION, STUDIO AREAS, HISTORY OF ART)

General Education Requirements

	Credits
English	6
Mathematics	6
* Social and Behavioral Sciences	9
The Humanities	9
Physical Sciences	6/3
Biological Sciences	3/6
	39

* Six of the nine semester hours of Social and Behavioral Sciences must be from the areas of History, Anthropology, Sociology, Political Science, Economics, and Geography.

For specific courses to complete these requirements, see page 123 through page 126 in this catalog.

Preprofessional Requirements

	Credits
ART 1201C, 1203C Beginning Design 1 and 2	6
ART 1300C, 1301C Beginning Drawing 1 and 2	6
ARH 2050, 2051 Intro to History of Art 1, 2	8
Electives	6
	26
	Total 65

NOTE: Students intending to major in art education are urged to become familiar with the requirements as listed under the College of Education dealing with admission to the Advanced Professional Sequence.

Suggested Course Sequence

FRESHMAN YEAR

	Credits
English	3
Social Science	3
Biology or Physical Science	3
ART 1201 Beginning Design 1	3
ART 1300 Beginning Drawing 1	3
	15

English	3
Social Science	3
Humanities	3
Biology or Physical Science	3
ART 1203 Beginning Design 2	3
ART 1301 Beginning Drawing 2	3
	18

SOPHOMORE YEAR

	Credits
Humanities	3
Biology or Physical Science	3
Mathematics	3
ARH 2050 Intro to History of Art I	4
Elective	3
	16

Humanities	3
Behavioral Science	3
Mathematics	3
ARH 2051 Intro to History of Art 2	4
Elective	3
	16
	Total 65

2. Curricula leading to the Degree of Bachelor of Fine Arts.

The Bachelor of Fine Arts degree offers programs in the following areas: (a) Studio—creative photography, drawing, painting, printmaking and sculpture, (b) Art History, and (c) Ceramics. Students who plan to enter a program of graduate study in art after receiving the baccalaureate degree are advised to register in one of these curricula. Upon completion of graduate work students entering these fields are

Curricula in Art
(continued)

qualified for positions in museums and art galleries, as instructors of art at the college and university level, or for independent activity as creative artists.

JUNIOR YEAR

	Credits
ART Specialization: 1st level	4
ARH 4453 Mid 20th Century Art	4
ART 33100 Intermediate Drawing 1	4
* General elective	4
	16

	Credits
ART Specialization: 2nd level	4
Art History	4
** Art elective	4
* General elective	5
	17
Total	33

SENIOR YEAR

	Credits
ART Specialization: Advanced	6
Art History	4
** Art elective	8
	18

	Credits
ART Specialization: Advanced	6
Art History	4
** Art elective	4
	14
Total	32
Total Minimum Credits	130

* Electives must include a minimum of nine credits outside the Department of Art in courses of a non-studio nature.

** Twelve credits will be chosen from: ART 3110C, 3510C, 3600C, 3400C, 3701C. Four credits will be chosen from: ART 3111C, 3311C, 3401C, 3520C, 3601C, 3702C. For Drawing majors ART 3310C-3311C will be counted as part of their studio major and they will substitute eight credits (to be selected from the classes listed above) to make up the difference.

*The University Record, Undergraduate Catalog 1983-84, (Gainesville, Fla.: University of Florida, Gainesville, Fla.), pp. 91, 93.

Contents of painting courses and the problems given are ordinarily at the discretion of the class instructor; only a rough effort is made to synchronize sequences. The instructors do get together on the information that must be covered. With such latitude, the problems vary widely. Jerry Cutler of the University of Florida arranges a set-up of white objects only. John Ward, art historian as well as studio teacher, has as a first project a set-up of brown paper bags. He also has students copy "old master" prints or extend their boundaries using the same style. Cutler arranges a set-up of hundreds of objects on tiers covered with drapes. Students select a section that is then painted quite descriptively. Cutler also creates colorful interiors that are lighted to articulate the objects, chairs, a bed, blankets, in dramatic space. Cast shadows create "mood."

I was once escorted into a large room at The Pennsylvania State University. It was filled with still-life material, hundreds of items, including a staircase on rollers that could be moved about to secure desired effects. Does the amount of still-life material make a difference?

Often a project having to do with the interiors of studios or the halls is given leading to landscape painting in the vicinity of the art buildings.

Instructors teach acrylic or tempera or oil underpainting and oil overpainting, glazing. They teach the use of colored grounds. They teach various ways to achieve tonalities and/or intensities. All of this comes under the

heading of "directed teaching," as will all projects up to and through the junior year. As a senior the student enters a phase known as "nondirected teaching." The students then devise their own problems and are encouraged to be "creative."

Over the years I've visited many art departments and have been impressed by the number of faculty who have virtually given up as producers of art beyond a piece or two for annual faculty exhibitions. Some schools have ceased having this event; it is too much trouble, I guess. Honesty requires me to tell you this. I have been depressed by the lackluster caliber of many faculties. In each faculty, however, I found one or two outstanding artist–teachers. As a student, you will discover who they are, and it will be the influence of these that will help sculpt the artist in you.

Generally speaking, I have found that instructors who administer projects as hurdles for you to cross and who tend to give great importance to their grades are the worst instructors. The best are those who identify with you as a peer, but a peer sharing hard-won experience. The most important things good teachers have to offer are themselves.

Art department chairpersons will be of some importance in your schooling, although they will be largely invisible to you. The chairperson keeps the budget effective, keeps morale high among faculty, and establishes the tone of the department in relationship to the other areas as well as to the university administration.

39.

Conclusion

Finally: I know of no professional area like art, where a näive individual can paint pictures that are matched with professionals in competition (where else can the beginner in any fashion compete with the professional?); but once committed to sophistication, art students must learn *everything* about their profession; then, and only then, are they ready to find themselves and rise above the herd to that select company of Rembrandt and other immortals of art. And it seems to me that none have any business in art unless they come to it with high ambition; and even if they fail, they will have led a better life than most people will have known. Painters sometimes know the joy of having created that picture which to them and in their terms has attained a seeming perfection. Painters come to this but infrequently, when they do there is great gladness. So there is joy for them as well as frustration in the engagement with their painting.

Beyond the personal satisfaction of life devoted to art lie more important reasons for such a career. This is the age of the community person, the organization person, the governed person. I believe that it is in the persistent effort of individual artists to maintain their personal identity that salvation of regard for the individual remains. Artists are at least a symbol of hopes Western man has known, and their presence is an insistent reminder that Western society must not lose complete sight of the individual.

Bibliography

Good art students are insatiable lovers of art books and periodicals. The following list comprises titles I feel to be necessary, if not required reading.

Collier, Graham. *Form, Space, and Vision: Discovering Design Through Drawing*. Englewood Cliffs, N.J.: Prentice-Hall, Inc., 1963.

Focillon, Henri. *The Life of Forms*. New York: George Wittenborn, Inc., 1948.

Haftmann, Werner. *Painting in the Twentieth Century*. New York: Frederick A. Praeger, Inc., 1960 (from revised German editions of 1954-55 and 1957), vols. 1 and 2.

Janson, H. W. *History of Art*. Englewood Cliffs, N.J.: Prentice-Hall, Inc.—Harry N. Abrams, Inc., 1962.

Lowenfeld, Viktor. *Creative and Mental Growth* (revised Ed.). New York: The Macmillan Co., 1957.

Lowry, Bates. *The Visual Experience: An Introduction to Art*. Englewood Cliffs, N.J.: Prentice-Hall, Inc., 1961.

Mayer, Ralph. *The Artist's Handbook of Materials and Techniques*. New York: Viking Press, Inc., 1948.

Pepper, Stephen Coburn. *The Work of Art.* Bloomington, Ind.: Indiana University Press, 1955.

Wolffin, Heinrich. *Principles of Art History.* (first published in 1915), 6th ed. New York: Dover Publications, Inc.

The Skira, Praeger, Abrams, and Museum of Modern Art publications and catalogs should be examined at every opportunity.

Index

FLORIDA STATE

ArT (220 E)

R/0845214TH

FROM TO EDGES
ip 57 ~
108 10d 2

FLORIDA STATE

ART (2301 C)

BJORNSETH

FROM	TO	~~EDAGES~~ PAGES
91	97	7
108	109	2